A Native Son's Story of Fishing, Hunting and Duck Decoys in the Lowcountry

A Native Son's Story of
Fishing, Hunting and Duck Decoys
in the Lowcountry

A CAINES FAMILY TRADITION

Jerry Wayne
CAINES

Charleston · London

History PRESS

Published by The History Press
Charleston, SC 29403
www.historypress.net

Front cover: A Fair Day's Hunt, depicting Chef Charlie McCants and Bob, Hucks and Sawney Caines. The painting, by Jerry W. Caines, measures twenty-four by thirty-six inches.
Back cover: Old Georgetown by Jerry W. Caines.

First published 2007

Manufactured in the United Kingdom

ISBN 978.1.59629.241.3

Library of Congress CIP data available.

I wish to give a special thanks to Buddy and Bobbie McCutchen for their nudging me in the right direction to write this book about our ancestors and our own lives here in South Carolina. Also, it was Buddy who wanted to see if I could carve a duck decoy and got us started in that direction. For this, both Roy and I truly thank him. It is in the warmest regards we wish to dedicate this book to Buddy and Bobbie. We would like them to know that they are very much appreciated.

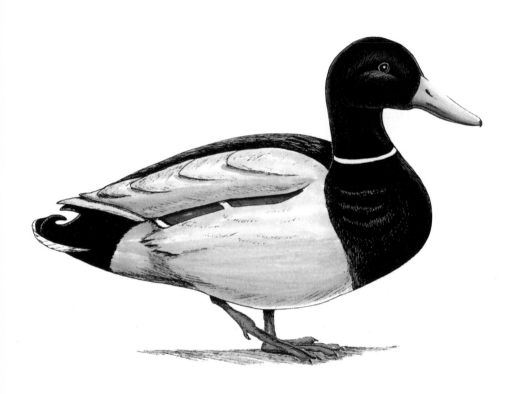

Contents

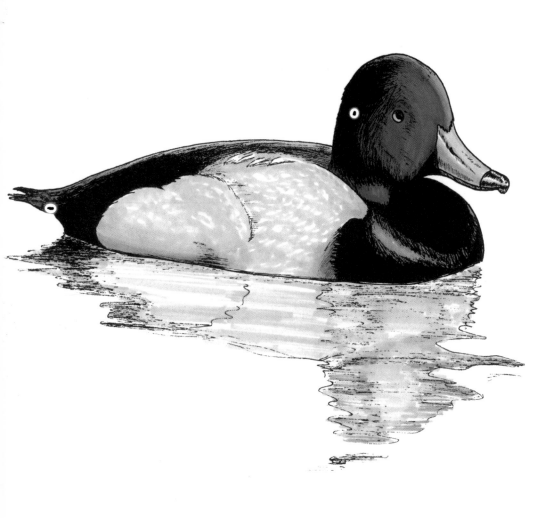

Acknowledgements

I wish to acknowledge the following contributors with thanks and appreciation for the many hours spent in research, obtaining data and information to help make this book possible.

Thanks to Harrell B. Caines, Patricia Ann (Caines) Holmes and Roy B. Caines for their help in the research and stories for the book. A special thanks also goes to Dick McIntyre—whose knowledge of the Caines brothers' decoys was most helpful in the writing of this book—and Lee G. Brockington with her knowledge of Hobcaw Barony, the Caines brothers and book publishing.

A special thanks goes to Debbie Summy, the director of the Georgetown County Museum, who allowed our artwork and decoy carvings to be displayed at the museum, the very place I started school in the first grade in 1955 and received my first artist's kit from a teacher who, early on, recognized my love for art.

Thanks also to Wesley Young, who just happened to have saved a few of the old black-and-white photos from our childhood and allowed me to use them.

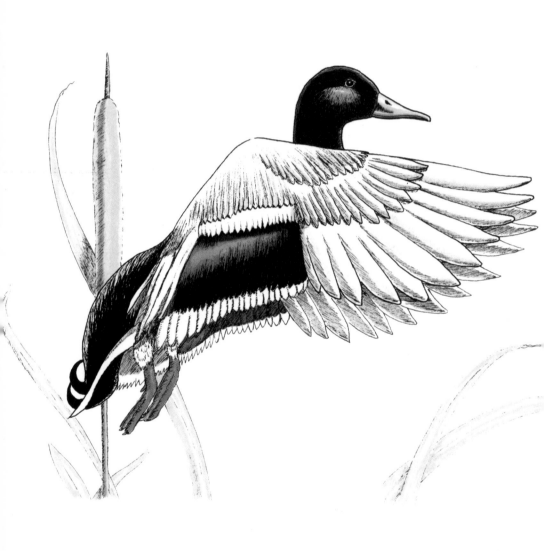

Introduction

Winyah Bay near Georgetown, South Carolina, and its tributaries—the Sampit, Black, Great Pee Dee, Little Pee Dee and Waccamaw Rivers—have set the stage for what history has declared "the Caines brothers' hell-raising territories."

It is the purpose of this book to tell the story of the not so famous, or maybe a little famous, Caines brothers and the carving of their duck decoys and their life and times in and around Winyah Bay. This includes their hunting and fishing skills while they served as hunting guides on Hobcaw Barony for the famous Bernard M. Baruch, a very cunning and skillful Wall Street financier and advisor to presidents.

Baruch had the foresight to maintain the plantation as a wildlife reserve, which is today the Belle W. Baruch Foundation, so named after Baruch's oldest daughter. The reserve educates on wildlife, marine science and forestry for college-level research. They worked for the Baruchs and lived on Baruch's plantation in a settlement called Caines on Baruch throughout the early 1900s.

Also related are my stories of my brother, Roy Caines, and me. Known in Georgetown as the Caines boys, we are the descendants of the Caines brothers. Of course, there are other brothers and sisters, but we are the ones who pursued a life of working on Winyah Bay and the surrounding waters to make our living as fishermen and shrimpers. Our life and times on Winyah Bay, and a few of our stories that have accumulated over the years of our fishing adventures, are presented here in this book.

We hope you enjoy the life and times of the Caines brothers and the Caines boys, as told through this book, *A Native Son's Story of Fishing, Hunting and Duck Decoys in the Lowcountry: A Caines Family Tradition.*

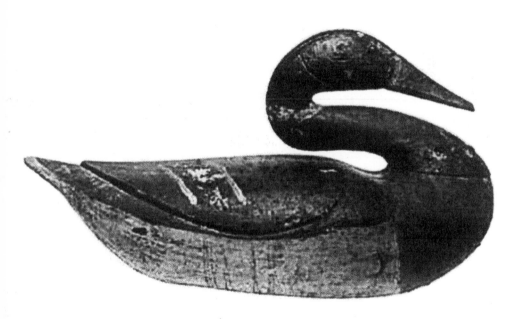

A Hucks Caines decoy. *Courtesy of the author.*

Chapter 1

The Caines Decoys

The Caines brothers are famous today for the carving of their duck decoys that were made and used for hunting ducks in and around Winyah Bay, just off Georgetown, South Carolina, around the turn of the century.

Little did the Caines brothers know at the time that they were, in fact, making art. At the time, there was no such thing as a store-bought duck decoy, no such thing as a plastic duck, as this hadn't come about just yet. So if you wanted to use duck decoys, you either had to make your own or have someone make them for you. In most instances, it was not the hunter who made his own decoys, but someone else who would actually whittle and carve them out of wood for the hunter.

The Caines brothers not only hunted ducks themselves, but also made their own duck decoys, which were used on their hunting trips. The Caines brothers duck decoys are considered by many to be the finest examples of South Carolina folk art in existence, as far as duck decoy carving goes. In fact, they are a true part of South Carolina history. Their duck decoys are considered sculptures in wood, as Dick McIntyre once stated: "You really have to think of them as ART."

The Caines brothers' ancestors had settled on Fraser's Point, a strip of land east of Winyah Bay, with a settlement that was settled mostly by the Caineses, dating back as far as the early part of the 1700s. The later Caines brothers were Hucks, Sawney, Ball, Bob and Pluty. For the record, here are their full names: Joseph Jenkins "Hucks" Caines, Richard Randolph "Sawney" Caines, Edmund Alston "Ball" Caines, Robert "Bob" James Donaldson Caines and Moultrie Johnson "Pluty" Caines. They had settled on a part of Muddy Bay, just off Winyah Bay and facing Pumpkinseed Island. The brothers named it Caines on Baruch, also known today as Caines Point.

When Bernard M. Baruch bought Hobcaw Plantation around the turn of the twentieth century, the Caines brothers had already settled on the land, as had their ancestors, and claimed squatter's rights to the property. It seems that they had been there forever, so that was home and it always would be.

Whether or not they ever had deeds to the property is not known. The brothers' fathers and grandfathers had always lived there and had a settlement with a graveyard that dates back to the early 1700s. Around the time of the Civil War, most of the land records had been destroyed.

When Baruch purchased the land, it was the custom at the time in South Carolina that when one bought a piece of property, the people who already lived there and called it home were allowed to remain there. And so the Caines brothers were allowed to remain on Hobcaw Barony.

The Caines brothers lived hard. They made moonshine and sold it as well as drank it, hunted and lived off the land. Baruch, knowing of their abilities, offered them jobs as hunting guides on the plantation. Besides, since they were already living there, he couldn't keep them from hunting on the land. Baruch called it poaching on his land and hunting illegally, but to the Caineses, it was like hunting in your own backyard; they didn't see it as poaching. Baruch thought it would make more sense to have them working for him, thereby keeping other hunters off the place. All accepted the offer to go to work for Baruch, except Ball, who refused to work for this man. He always felt that Baruch had stolen the land from the Caineses and he simply didn't like him.

The brothers had a real flair for their carvings in the making of duck decoys, and Baruch used them almost exclusively in his duck hunting trips. It has been noted that the brothers were as daring with their carving as they were with their lifestyles. The decoys were carved down to the very best and finest of every minute detail. It has also been noted that the decoys that they carved were considerably larger than most other handmade decoys, making them unique.

The reasoning behind the oversized decoys was so that ducks could see them from great distances, making them most effective at bringing the real ducks in closer. It was not until the mid-1980s that the duck decoys attracted attention. At the Southeastern Wildlife Exposition in Charleston, South Carolina, in 1988, a couple of men who had bought a Caines decoy for a mere $25 the year before in 1987 put it up for sale at the exposition auction. Once the bidding started, it was a frenzy. That one decoy sold for $35,000. At least, that is the story I was told, I can only assume that it is true.

Anyway, word got out about the sale. A Charleston magazine had put out a story that implied that if one owned a Caines decoy, it could bring in a possible $50,000.

Needless to say, there was a frenzy of local people trying to locate a Caines decoy. We even had people coming by our home, as well as calling us on the phone, in search of the famous decoys, only to be sent away in disappointment. At one time, we did have a couple of fish boxes full of them; that was in the '50s and '60s. My father kept them under our house, to keep them out of the weather. In 1967, when my parents purchased the home we live in today, there was no room to store them inside the home. This house is also too low to the ground to make use of any kind

The Caines Decoys

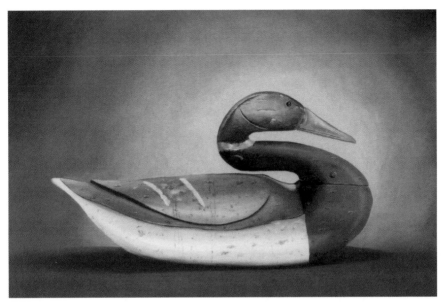

A Hucks Caines decoy made into a painting by me, Hucks's grandson, circa 2005. *Courtesy of the author.*

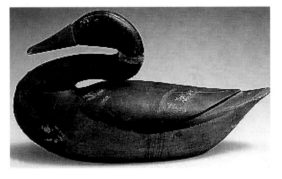

When this circa 1910 mallard with the S-shaped neck by Hucks Caines of Georgetown, South Carolina, came up for bid, it was figured that some folk art collector would buy this remarkable piece of folk art. Dealer Stephen O'Brien hadn't intended to bid on it, but when he saw it going for under $200,000, he took it for $189,500. *Courtesy of the author.*

of storage underneath. My dad used the shed to store all of his fishing nets and other related stuff, to the point that it was piled up to the door. Since there was no room for the decoys to be placed in the shed, he put the boxes of decoys under the eve of the shed, where they stayed until they were rotten beyond recognition. But hey, in those days, they had no value, none whatsoever. No one cared and no one knew what the future might bring.

It should also be stated that not all Caines brothers decoys are considered highly valuable; the ones that have the most sculptural examples in their original surfaces have nearly unlimited appreciation value. I was once told that Dick McIntyre, a duck decoy collector and broker, had a Caines decoy that he sold to a man for $45,000 and was sold at an auction the following year for $189,500. It was a snakey-neck mallard and it was sold at Oliver's in Maine. I know for sure that a Caines

15

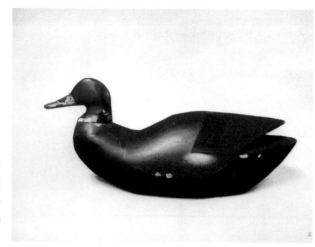

My January 2005 painting of a black duck decoy carving by Hucks Caines. *Courtesy of the author.*

decoy sold at Oliver's for this amount, but whether it was ever owned by Dick McIntyre, I can't say for sure.

Some woodcarvers believe that a good artist is one who doesn't follow the crowd, but breaks his own trail. That is precisely what the Caines brothers did. They carved to suit their own taste and their own need, which is what makes their carvings so outstanding and different from other carvers. Their work has now been recognized throughout the art world as real collectors' items with great value.

The South Carolina Caines brothers decoys are not as available as those from other carvers throughout the geographic regions, such as the Cobbs, Hudsons, Wards and Crowells, which outnumber the Caines brothers decoys by far. The Caines decoys were completely unknown to collectors, but as their emergence becomes more public, they can finally be appreciated as among the most sculpturally refined examples of decoy art.

There are approximately fifty known examples of the Caines brothers duck decoys that still exist today. From the wonderfully elegant snakey-necks to the primitive split-tail hen mallard, each decoy exhibits a continuity that is apparent to all who study the progressive, stylistic periods in a great carver's career. The slope of the breast, the rounded neck seats and the shallow behind the neck, which helped hold the anchor line, are all unusual, shared characteristics of the Caines decoys. The raised-wing carvings have a variable height from approximately ⅛-inch to almost ¾-inch on the larger, oversized birds. These larger decoys, some with support pegs under the bills, are referred to locally as raised-wing or peg beak decoys. It's these characteristics that make the Caines decoys stand out and are recognized without a doubt as being a Caines brothers decoy.

On July 11, 1992, for the first time since the peak decoy auction year of 1986, a wildfowl decoy sold for six figures. At the tenth annual Important American Waterfowl Decoys Auction in Kennebunk, Maine, a Caines brothers preening

The Caines Decoys

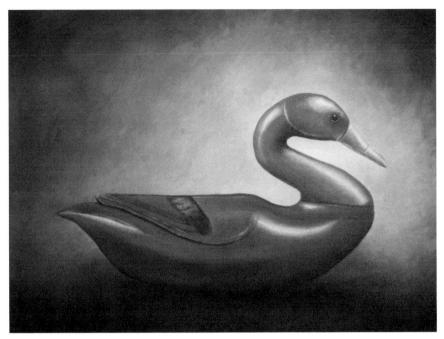

My 1998 painting of a snake-neck mallard drake by Hucks Caines. *Artist's own collection.*

mallard drake brought a successful $165,000 phone bid shortly after bidding opened. Immediately afterward, its mate, a snakey-neck mallard hen, also went over estimate to the same phone bidder at $92,500. That's a total of $257,500 for the pair.

Needless to say, that is a record by itself. That's over a quarter of a million dollars, which is an auction record for a pair of decoys. The Caines brothers preening decoy set a record as the fourth decoy ever to sell at auction for over $100,000. The successful buyer of both birds was later identified as not being a decoy collector at all, but Maresca-Rico, a well-known American folk art dealer from New York City. It was stated that the pair of decoys would ultimately be part of a collection of masterpieces of folk sculpture.

It was good that the pair were kept together, as they had always been kept as a pair. Believe it or not, the pair was consigned by the estate of the late Tom and Jean Yawkey, who owned the Boston Red Sox. Tom A. Yawkey owned a plantation named for the island where it's located, South Island, and were neighbors of mining tycoon Joseph Napoleon Wheeler, who was the first documented owner of that Caines pair of decoys.

Wheeler had given the pair to Tom Yawkey in the mid-1930s as a gift to him and his wife. The Yawkeys sold some of their personal property in the late 1950s, which included some furniture, and the decoys went along in the trade. Then, in the early part of the 1960s, the Yawkeys bought the property back, which luckily included

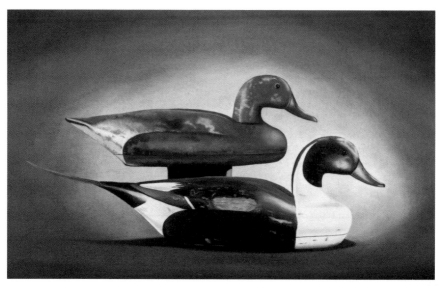

My May 2005 painting of a pintail drake and hen carved by Hucks Caines. *Private collection.*

the decoys. They sat on the mantel at the Big House on the plantation until they were given away as gifts.

There was quite a gap between the prices of the Caines pair and that of the next highest-priced decoy, which sold for $21,450 at that year's auction. The combined cost of the Caines pair was 42½ percent of the auction's gross.

The decoy broker Dick McIntyre once stated, "I believe that I will live to see the day, when a wonderful example of a Caines brothers decoy will bring in over a half million." McIntyre also stated that he had been to the Shelburne Museum in Vermont and viewed some of the finest private decoy collections in America, but when Tom Lee—a collector in Georgetown, South Carolina—first showed him a Caines snakey-neck hen mallard, he told him that it was the greatest decoy he had ever held in his hands.

These decoys are distinctly different from any others found along the entire Atlantic Coast and exhibit unique characteristics. It is obvious that the Caines brothers were influenced only by their own creative impulses. They made mostly black ducks and mallards in at least four entirely different styles, leading to the speculation that each of the five brothers—Hucks, Ball, Sawney, Bob and Pluty— may have carved his own individual decoys. Many of the decoys are oversized, some hollow carved and some solid, with most having some form of the raised-wing carving that the brothers were famous for. There are a few pintail decoys and several blue wing teal decoys that are also attributed to the brothers.

The legacy that the Caines brothers left for carvers and decoy collectors throughout the United States has become the most admired and appreciated by collectors of American folk art everywhere.

Chapter 2

Hobcaw, Baruch, the Presidents and the Caines Brothers

If you ever have the chance to visit this place and get to see the sunrise break over the horizon and peer through the trees with its glistening rays, and you look up and see the tops of the pines waving in the wind, with the deep blue skies above and the songbirds singing to greet the new day, you know you have found a little piece of what is called heaven on earth. And that explains why the Caines brothers settled at this place called Hobcaw Barony.

The Caines brothers were commercial fishermen and gunners/hunters from the mid-1800s up until they were hired by Bernard M. Baruch as guides for his plantation and hunting trips for his guests. They lived in a settlement called Caines Village by Baruch, although the brothers preferred to call it Caines on Baruch.

They lived there just as their parents and grandparents before them had done. They had worked initially on the rich plantations that made up most of Hobcaw Barony after the Civil War, primarily as watermen, hunters and fishermen. As was the custom in the South, when Baruch purchased the plantation, the tenants and their settlements were included with the purchase. So it was that by 1905 the Caines family village became the property of Baruch. Combined with the other coastal plantations he had acquired, Baruch's holdings totaled over 17,500 acres of the finest winter waterfowl habitats in the world. The word "Hobcaw" is said to be an Indian word that means "between the waters." The name was given to the plantation because it lies between the Waccamaw River and the Atlantic Ocean, making it between the waters.

Once Baruch had made the purchase, the land became privately owned. Well, for years previously, the Caines brothers had shot ducks and other wildlife birds on the surrounding rice fields and marshes to sell at Crowley's Market in Georgetown. During the fall and winter months, the sale of fowl was their primary income.

The brothers were perplexed by the sudden fact that the land was now privately owned and posted against trespassing to all hunters, including them.

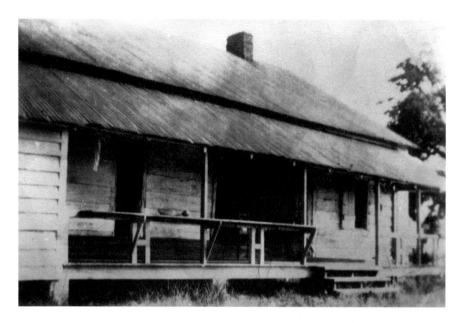

Above: The backside of the house on Clambank where Hucks lived, about 1912. *Courtesy of the author.*

Right: Hucks Caines Sr. beside one of his sailboats with a helper, name unknown, circa 1920s. *Courtesy of the author.*

The Caines brothers rebelled! So much so that they increased their hunting activity on Hobcaw until Baruch claimed the activity was nothing more than "poaching on my land."

In Baruch's autobiography, he recalls apprehending Hucks Caines one morning with 166 mallards and black ducks in his possession. Following the ensuing confrontation, Hucks was promptly employed by Baruch to do what he had always done in November: hunt ducks! Only now, Baruch required Hucks to take his guests out with him, as their guide. This way, Baruch could keep an eye on him and help cease the poaching by the brothers. His plan worked.

Baruch stated that Hucks had become his favorite guide, and his knowledge of the ways of waterfowl became legendary. Baruch also stated, "This man knows more about ducks and waterfowl than anyone I have ever met."

Hobcaw, Baruch, the Presidents and the Caines Brothers

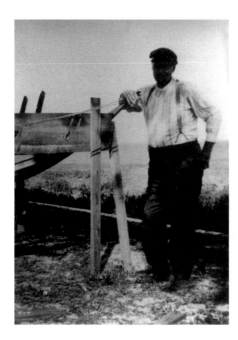

Hucks Caines Sr. building one of his sailboats, circa 1920s. *Courtesy of the author.*

On their hunting trips, the hunting groups used the very decoys that the brothers had made. It was thought that the brothers had made the decoys to use for themselves and had never made them to sell. However, more recent research into the Caines brothers decoy production has provided strong evidence that they had made decoys and brought them to Crowley's Market on Front Street, in Georgetown, and put them up for sale. This is believed to have helped them get through some of the harder times in the winter months.

The Caines decoys were used on most of the rice plantations from the Santee River delta to North Island. One could find rigs of decoys that consisted of Caines decoys, Dodge and Mason factories decoys all bunched together. Harry V. Shourds and some well-crafted Delaware River decoys seem to be found most often with the Caines birds.

The number of decoys made by the Caineses is probably in the hundreds. The exact number is not known for sure, but it is believed to have been around 550 decoys. The original Hobcaw mansion burned to the ground in 1930. The boat storage shed, where most of the decoys were kept, burned in 1951. Neglect, termites and powder-post beetles further reduced today's existing numbers. A few were kept at Hobcaw, but have since disappeared.

The first president of the United States to visit Hobcaw was Grover Cleveland. One of the choicest hunting sites on the plantation is called President's Stand and it was so named in his honor. The official local pronunciation of President's Stand puts the accent on the last syllable of "President's" and how it got its name was one of Baruch's favorite stories.

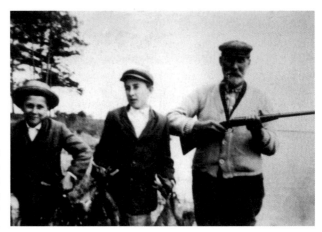

Emory and Bud Caines and Richard Randolph "Sawney" Caines in 1913 after a day's hunt for ducks. *Photographer unknown.*

The story was told to Baruch by Sawney, who was the president's guide at the time he was visiting. As Sawney used to tell it, he had rowed the president to the edge of the marsh grasses, with both of them concealed in the boat under palmetto limbs and branches. They moved about quietly and set out the decoys that they had brought along and then proceeded to the shooting stand. This meant that they had to walk over a strip of oozing mud, called pluff mud, which bordered the creek bank.

As Sawney would say, "Walking on mud like this is quite an art. You must put your foot down lightly and raise it quickly, so as not to sink too deeply." Since President Cleveland's normal body weight was well over 250 pounds, you can appreciate the complications that followed.

Sawney was lending a hand and doing all he could to help support Mr. Cleveland's bulk, when suddenly the president's arm slipped from Sawney's shoulder and down the president sank into the muddy marsh amid the soft pluff mud.

The very thought of the president of the United States becoming stuck in the mud and sinking deeper all the time generated superhuman energies within Sawney. He grabbed a strong hold on Cleveland's body—which was not an easy task on the president's round form—and gave a mighty heave and out came the president. However, his boots did not. Both of the president's hip boots stayed right where they were, deep in the mud. The president himself was lifted out high and dry in his stockinged feet.

In rescuing the president, Sawney himself sank nearly waist deep in the ooze. Of course, he knew what to do to get himself out and once he had, the two decided to get back to the boat. Working their way back to the boat was not an easy task either, but they managed to make it. Both of them were pretty well plastered in mud, so they decided to end the hunting trip and head back to the big house. Sawney wanted to take the president back to the plantation straight away, but Cleveland insisted that they retrieve the decoys first. Once back on dry land and after washing

The Hobcaw House as it is today with Roy Caines in front of the door and Harrell Caines in the foreground, January 2005. *Courtesy of the author.*

off the mud, they changed into warm clothing and were "medicined," to use Sawney's tactful and colorful word.

After a few swallows of good stiff "medicine," Mr. Cleveland began to shake with laughter, at which Sawney said he was never more relieved in his life. The thought that it was he who nearly caused the president of the United States to drown in mud was more than he could bear. As it was a serious matter to Sawney, whenever he told the story he would never crack a smile. To him, it was not a laughing matter.

President Cleveland was not the only president to visit Hobcaw. In April of 1944, President Franklin D. Roosevelt made a trip to visit Baruch at his famous Hobcaw Plantation. World War II was in full swing and Roosevelt was overburdened with his crunching war responsibilities, but still he knew that no man could be too busy not to stop and take a rest from time to time. Roosevelt had planed to make a stay of only two weeks to obtain this much-needed rest, but upon enjoying the plantation so much he extended the stay for an additional two weeks, remaining for an entire month.

Another visitor of great distinction was Winston Churchill, along with his daughter, Diana. They came for a brief visit in 1932. They had been vacationing in Bermuda and had heard of Hobcaw and wanted to pay a visit; besides, Churchill was already friends with Baruch, and wanted to pay him a visit, too.

Many of the guests who had visited Baruch at Hobcaw were political leaders. One regular visitor was the governor of South Carolina, Richard I. Manning, who would come to officiate over an annual deer drive.

The woods and fields in and around Hobcaw were teeming with all sorts of wildlife, including wild hogs and wild boars, foxes, possums, coons and at one time even wildcats and otter. There were many types of birds, such as woodcock, jacksnipe, quail and wild turkey, but first and foremost, Hobcaw was known for its ducks. Baruch once stated, "I don't believe that there is a better place for shooting duck in the whole United States, than Hobcaw." He even went so far as to state, "I

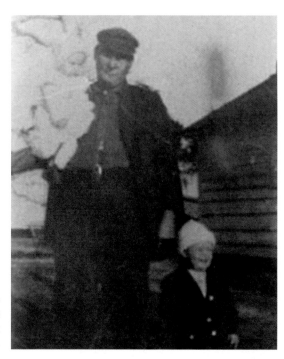

Joseph Jenkins Hucks Caines Sr., possibly with children Bertie Ray being held and Ruby Violet standing. *Courtesy of the author.*

have hunted in Scotland, Czechoslovakia, and Canada, but never in all my travels, did I ever come upon a place to compare with Hobcaw, when it was in its prime, for the abundance and variety of its game."

With so many ducks in and around Hobcaw, this led to a great deal of hunting by the surrounding population, including the Caines brothers. Since Baruch had purchased the plantation, it became private property. Well, this opened the door to a good deal of poaching, which in turn almost cost Baruch his life. Let me tell you this story.

When Baruch first purchased the plantation, its marshlands were under lease to a club of Philadelphia sportsmen. As the story goes, these club sportsmen were having a running dispute with four of the Caines brothers over their poaching. Since the Caines brothers had lived on or near Hobcaw for generations and claimed some property rights, they felt they had the right to hunt there as well as anyone else.

One day, Ball and Hucks sailed their boat right up to where several club members were shooting for ducks on their hunting trip. They stopped the boat just offshore of the hunters and with double-barreled shotguns across their laps they began cursing the Northerners and told them just what they thought of Yankees in general. Well, this word spread and everyone knew the way the Caines brothers had ruined the hunting club strip, but nothing could be done about it, since the brothers were staying in their boat and were not technically poaching at the time.

Hobcaw, Baruch, the Presidents and the Caines Brothers

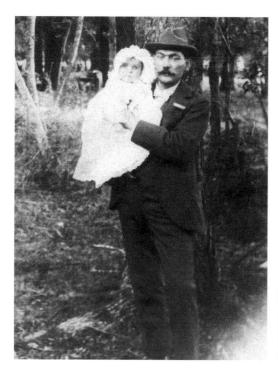

Edmund Alston "Ball" Caines holding his granddaughter, Mary Elizabeth Caines, who was six months old. The photo was taken in Georgetown, South Carolina, circa 1912. *Photographer unknown.*

One morning, Baruch spotted Hucks on his land and knew he had been hunting there. Baruch approached Hucks and confronted him sternly, but wound up asking if Hucks would consider working for him instead of poaching on his land. Hucks agreed and went to work for him and believe it or not, they became the best of friends.

Baruch could never induce Ball Caines to quit poaching. He resisted all the threats and persuasions that Baruch could throw at him. After Baruch had done everything possible to try to convince Ball that he meant business, he had Ball and another poacher arrested and sent to jail for nine months. To show that he simply wanted Ball to quit poaching on his land and really meant no harm to him at all, while Ball was in jail, Baruch had his lawyer look after Ball's wife and children. When Ball was released from jail, he came out looking for trouble. He was set to make things even with Baruch for having him jailed.

One day not much later, Hucks had taken Baruch out hunting for duck at President's Stand. With the hunting trip over, they were heading back to the landing in their boat. Hucks was rowing and as they approached the landing, Hucks told Baruch in an alarmed voice, "Mr. Bernie, Ball is on the landing and you had better be careful, it looks like he means business!" Hucks started to turn the boat around when Baruch told him to row straight in to the landing, which Hucks did.

As Baruch climbed out of the boat, Ball came running up and cursing at him in all sorts of foul language and swore that he would send his soul straight to hell!

Ball raised his double-barrel shotgun up and pointed it straight at Baruch. Baruch stated later, "I can still see those barrels today, I felt that I could have jumped into them without touching the sides." Baruch also added, "I was frightened that I mechanically walked right up to Ball and asked, 'Ball, do you realize just what you are doing?'"

Just as all this was going on, one of Baruch's employees, Captain Jim Powell, came running toward the landing with his big six-shooter in hand. As calmly as Baruch could, he said to Ball, "Here comes Captain Jim," turning his head slightly in the direction Captain Jim was coming from. Ball turned for a moment and at that instance, Baruch grabbed the barrels of the big shotgun and pushed them up toward the sky. Captain Jim grabbed Ball on the shoulder and told him that it was over and he should just accept it for what it was and let it go. Ball lowered the gun and the incident was over.

After that, Baruch's poaching troubles subsided. Baruch even promoted Captain Jim to be his superintendent over the entire Hobcaw Barony. Captain Jim was a tall six-foot-four-inch, raw-boned and fearless individual who was also a friend to the Caines brothers.

Baruch also said, "It has always troubled me, that I had put a man into jail just for shooting ducks. The ducks themselves did not matter, but I knew that if Ball was allowed to hunt on my land, everyone else would come to shoot and soon, my place would be a rendezvous for poachers. I would not receive any respect from neither poachers, nor anyone else."

Baruch was good friends with Hucks Caines and stated that he was glad that he didn't have to take such drastic measures with Hucks as he had with Ball. Hucks had such a wonderful sense of humor that it was great just to be around him. Once while hunting ducks, Baruch had missed a shot and offered Hucks some lame explanation for having missed the shot. Hucks simply stated, "Well, a poor excuse is better than no excuse at all, I guess."

Once, Baruch had four guests who were senators: Joe Robinson of Arkansas, Pat Harrison of Mississippi, Key Pittman of Nevada and A.O. Stanley of Kentucky. They had just come back from shooting ducks and were getting into the buckboard to drive home when Baruch remarked to their guide, "Hucks, do you know that these gentlemen are the senators who make the laws up in Washington?" Hucks leaned on the front wheel of the buckboard and asked, "Is they really the gentlemen who make the laws, up in Washington?" "Yes, Hucks," came the reply from Baruch. "Well," said Hucks, "if they don't know no more about other things than they does about whiskey and ducks, then this country is in one devil of a fix, cause they sure can't shoot and they can't hold their liquor either."

There were so many ducks on and around Hobcaw that any time a hunting party went out, they never had a bad trip. Baruch stated that on one occasion, after a hunting trip, they had laid the day's kill around them for a count, and the ducks

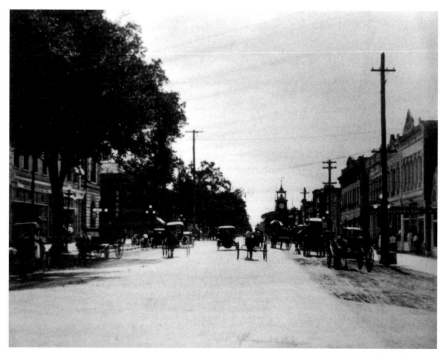

Front Street in Georgetown, circa 1906. *Courtesy of the author.*

Front Street in Georgetown, circa 2006. *Courtesy of the author.*

Rene Cathou in the fish house, sitting just outside of the office, April 1983. *Courtesy of the author.*

went out in a circle to over 120 yards. This is what they had brought back from that single hunting trip, which was one of the biggest hunting trips they ever had. Just how many were left behind is anyone's guess.

For retrieving the ducks, they had tried using retrievers, but the oyster shells would cut up their feet so badly that they couldn't use the dogs. This is where a good guide could come in handy. A good guide's job is to keep count of the birds you shoot and where they have fallen. Baruch once stated, "I have seen Hucks Caines pick up all but two or three birds, when the bag was close to two hundred. Not many guides could do that, and even a good one, had trouble keeping up with Hucks Caines."

The Caines brothers lived in a hard time. The Caineses' tale is one of poor, rough, uneducated men who nevertheless commanded respect for their skills as outdoorsmen. They lived hard, drank hard, fished in waters they were told to stay out of and poached on property that wasn't their own. As Raney Y. Cathou, a fish house and railway operator from Georgetown, once stated, "You have to understand about these people, they were watermen. They were squatters. And they lived on a place called Caines on Baruch. You didn't push these men around. The brothers were known for other activities besides the hunting, fishing and carving of decoys. The Caines brothers made liquor and sold it, too."

As exciting as all this sounds, here are a few words from Bucky Watkins, who grew up on Pawleys Island, just north of Georgetown. Watkins had listened to

stories about commercial fishermen in the Georgetown area in his school-age days. He even went to school with the descendants of the Caines brothers, including my brother Roy and me.

Watkins stated, "I just think it's a lot of hype!" To Watkins, the decoys that are worth so much money now are just the surface of a much more important story. Watkins—a former commercial fisherman himself who once ran a cargo business in Greenville, South Carolina, and now owns The Big Tuna, a restaurant in Georgetown—has a more important story to tell about the Georgetown-area commercial fisherman, his fading lifestyle and the legacy of the Caineses.

Watkins said,

> *I think people made a lot of money off of something that the Caineses never made a dime from and their families are still out here fishing with two little boats, scrapping for a living. And one of their grandfather's decoys sells for thousands of dollars, it's just not right…I know two of them* [Roy and me], *went to school with them and they're still in the same spot as three generations ago, exactly the same spot. Standing on the very same docks, where their forefathers had, doing the same kind of work, living off the land. And they have never gotten an even break.*

This is from an interview with Bucky Watkins by Aida Rogers. Watkins was standing on that dock in Georgetown just minutes before Roy and I appeared in our shrimp boats, tying up to the dock of Rene Y. Cathou, the fish house operator, just like our grandfather and his brothers before us had done. After unloading the day's catch, we were mending our green nets with a happy-go-lucky spirit. Aida Rogers stated,

> *They are today's Caines brothers, laughing and happy, content with their "simple" lives spent fishing the same waters as their father, grandfather and great-uncles. It's not hard for them to talk about the moonshine Hucks and Hucksie, their late father, made and sold. Nor do they deny the heavy drinking and poaching that went on in previous generations. Poaching was a way to survive a hard life and support the wife and children, they make no excuses and they don't apologize for it either…Hunting and carving means little to them, although Jerry paints wildlife paintings and sells and exhibits his work. Maybe he inherited some of the Caineses' artistic talent. There are no decoys left in the family, aside from the cheap plastic ones their father used later. People came looking for decoys after that newsmaking sale at the wildlife exposition, and expressed disappointment that the Caines family hasn't reaped any financial rewards from the decoys.*

Clam bank at high tide, sometime in the 1950s. *Photographer unknown.*

Clam bank at low tide, circa January 2006. *Courtesy of the author.*

Hobcaw, Baruch, the Presidents and the Caines Brothers

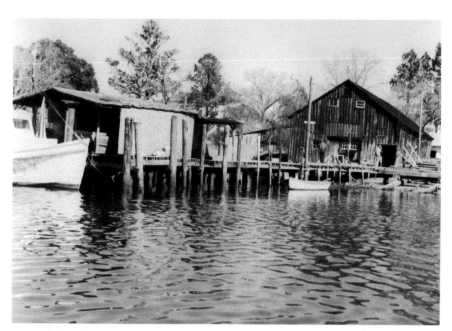

Cathou's Fish House in April 1984 with the shrimp boat *Joey C.* at the end of the dock, Rene talking to someone in front of the doorway and Anthony Hyman standing on the dock. *Courtesy of the author.*

Rogers asked Roy what he thought of this and Roy simply stated, "They're making money off of us, but that's just the way life is, I reckon." Rogers continued,

> *Jerry and Roy don't dwell on it, but Watkins does! Watkins can show you where the Caineses lived on Baruch Shore and how there's nothing there today. And he can tell you how he regrets not taking pictures of sturgeon fishing and caviar rubbing, something that doesn't happen anymore. Jerry and Roy did this type of fishing themselves. Dressed sturgeon, rubbed out caviar and all! Watkins will tell you, if anybody ever lived, it was the Caines brothers and now, the Caines boys.*

Chapter 3

Hucks Caines Jr.

His Life and Times

Hucks Caines Jr., known as Hucksie, was one of three children of Hucks Caines Sr. Hucks Sr. had two girls—Ruby, the oldest, and Bertie Ray, the second girl—and Joseph Jenkins Hucks Caines Jr., the youngest. Hucks Caines Jr., "Hucksie," was our father. He married Jeannie Veona Rourk of Shallotte, North Carolina, on April 11, 1936, in Conway, South Carolina. They had a rather large family that consisted of seven children. The first-born was Joseph Jenkins Hucks Caines III, but sadly, he lived for only a few hours and passed away on June 10, 1937. Hucks III was buried in the Caineses' graveyard on Fraser's Point on Hobcaw. Our father, Hucksie, and his cousin, Bud Caines, made a coffin of pine and placed the child in it, took it by rowboat across Winyah Bay to the Caineses' graveyard and there they placed it in the ground. This child was placed in one of the corners of the graveyard, but today it is unmarked.

Next, in 1939, the couple gave birth to Harrell Bell Caines. Two years later Carol Jean Caines was born and then two years after that William "Billy" Hucks Caines. There was a small spell of four years, then they had three more children: me (Jerry Wayne Caines), born in August of 1948; Patricia Ann Caines in 1951; and finally Roy Brooks Caines in 1952.

Hucks Jr. was born on September 18, 1908, at Clambank, which was part of the Caines settlement on Hobcaw Barony. He went to school in Georgetown, but spent most of his childhood at Hobcaw, North Inlet and the surrounding marshes, learning to hunt like his father and uncles before him. I know very little of his childhood, as he never spoke of it. I do know that he loved to hunt and fish, as he has always had this in his blood.

When I was old enough, I would go fishing and shrimping with him. Both Roy and I worked with our dad on his forty-eight-foot shrimp boat, the *Cool Breeze*. This was in the early part of the '60s. We enjoyed working with him, as he treated us just like deckhands; we cleaned the deck, handled the rigs, iced the catch, unloaded at

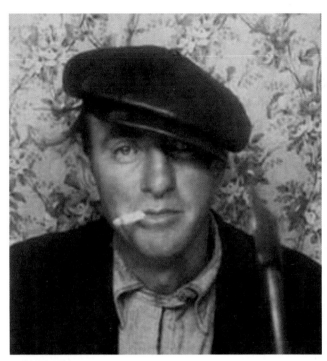

Right and below: Joseph Jenkins Hucks Caines Jr. *Courtesy of the author.*

Joseph Jenkins Hucks Caines Jr. in his early childhood, around twelve or thirteen years old, somewhere in Georgetown about 1920. *Courtesy of the author.*

the dock and got paid! We only worked through the summer months, as we were still in school, which would start up again in September.

Hucksie had a similar experience to his father's when Hucks had met Baruch, only our father was meeting Tom A. Yawkey, the millionaire who owned South Island Plantation, for the first time. The story goes something like this: Hucksie, our father, was hunting on South Island in the fall of the year in the early '60s. As the story goes, Yawkey had heard the sound of shooting and went to investigate the noise. What he found was more than he had bargained for! Upon approaching Hucksie, he walked right up to him and they both stopped what they were doing and stared at each other. Then, Yawkey asked, "What are you doing here on my land?" To which Hucksie replied, "Why, I'm hunting, what's it to you?" Yawkey replied, "Well, you can't be here, this is my land and there's no hunting allowed." Both were silent for a moment, and then Yawkey asked, "Do you know who I am?" To which Hucksie replied, "I don't give a good goddamn who you are!" Both stood there in silence for a moment and then both burst out laughing! What happened next was funny: Yawkey asked Hucksie if he would like to go to work for him, to keep other hunters off his land. Hucksie accepted and went to work as the official watchman of South Island.

Yawkey gave him a cabin to stay in on South Island and a Jeep to make the rounds. He only worked for Yawkey during hunting season, the winter months. From time to time, the family would go with Hucksie and spend the weekend down on South Island. We kids would go out on the rounds with him. This was so much fun. We really enjoyed those trips and the time we spent on South Island.

Hucks Caines Jr.: His Life and Times

Hucksie after a hunting trip for small birds, circa 1922. *Courtesy of the author.*

We were always safe when we were with our dad. Hucksie had such a reputation and carried a big Colt .45 revolver that no one ever wanted to tangle with him and they never did.

On one occasion, a couple of fishermen buddies Hucksie knew came ashore on the southern end of South Island to check on their outboard motor. They wanted to see if they had done any damage to their propeller, because they had bumped bottom.

Well, as luck would have it, our dad happened to be on that end of the island that day. He drove the Jeep right up onto the beach where they were and inquired as to why they were there. "Just checking out our propeller, Hucksie," came the reply. One of the men, Wayne Jordan, asked, "Hey Hucksie, you still carry that big gun with you?" "I sure do, got it right here," came the reply from Hucksie. "Don't worry, we ain't doing nothing wrong, not as long as you got that big gun with you! Heck, we ain't gonna do nothing wrong around here even when you don't have that big gun with you, we know you too well to do anything wrong." Of course, they were all good fishing buddies and nothing really happened. They spent more than an hour just sitting there, talking and shooting the breeze. Our dad had a lot of friends and it seemed that everyone in Georgetown knew him. The town was somewhat smaller in those days.

I remember going hunting once for ducks with my dad and a friend. We spent all morning out there and never fired a shot! We only saw one duck and it was too far away to even try a shot. Our dad began telling us about the times when he would go hunting and the sky would be completely filled with ducks. All you had to do was point the gun up and shoot. You couldn't miss.

I also remember going to South Island and seeing Yawkey have his ponds filled with wild ducks. You see, he had the ducks fed every day. They were so tame that they would cover the boat that they were fed from, to the point that you couldn't see the boat or the man who was throwing the corn. This was a spectacular sight to see. I will never forget it for the rest of my days.

It seems that things were always done on a huge scale, in those days. Even when Hucksie went fishing, it seemed he always had a big catch. I don't know whether he was just lucky or if was truly skilled at what he did.

When we were old enough, both Roy and I would go haul-seining with our dad and it would truly be an experience. All we ever did was make one haul, as that was all that was ever needed. We would take the smaller shrimp boat that our dad owned, the one we called the *Chris Boat*—so named after its builder—and tow a smaller skiff behind it until we got to the fishing grounds. Then we would anchor the *Chris Boat* and use the skiff with the haul-seine net in its stern.

We would not use any motor, but would row the boat along the shore. My dad would stop the boat every now and then and watch the surface of the water. He would say things like, "Okay, here they come, keep quiet." To this day, both Roy and I have no idea as to what he watched for or saw, but see them he did. He would say, "All right, there they are, let's go get 'em!"

We would place one man on the shore to hold a staff that had the net attached to it, both the top and bottom lines. The man on the shore would drive the staff into the sand and hold against the staff as the boat would be rowed away from the shore, thus pulling the net out of the stern as we rowed offshore. I would row the boat out a little ways, make a turn and row down the shore and then turn and head back to the beach. I only made these turns when my dad waved his arms to signal me when it was time to make the turns. This would surround the school of fish.

When the boat was back onshore, we would haul the net in by pulling on both the top and bottom lines. One particular day, we caught so many fish that Roy and I couldn't even pull the catch in. The fish would literally drag us out to sea. Of course, Dad and the other man that came with us, Frank Smalls, did most of the pulling. Once the net was brought into the shore and up on the beach, it would take us most of the day to get the catch into the *Chris Boat*. We would load up the skiff with baskets of fish and take them out to the *Chris Boat*, put them into the hold and ice them down. Then we would go back to the beach and get another load. This would go on all afternoon. We would always have around two to three thousand pounds of fish. We would take them back to our fish market and sell what we could, and then sell to other local fish markets, too.

There were so many fish that my parents were afraid the fish would spoil before they could sell them. They would sell to other fish markets in the area, like Rene's Fish House. Our parents also sold to fish truck carriers that would carry the fish to other states. The fish would be shipped to markets in Georgia, North Carolina and

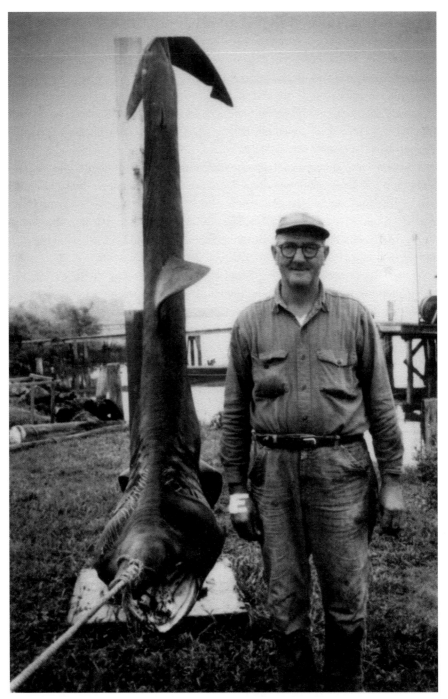

Hucksie and his sea monster, a basking shark, at the Esso dock in Georgetown in 1965.
Photographer unknown.

as far away as New York. These trucks came by on a weekly basis. They came not only to purchase fish, but to sell us fish, too.

Needless to say, both Roy and I would be totally exhausted by the end of each of these fishing trips we made with our father. Although it was a lot of fun, it was a lot of hard work, too. What boy wouldn't like to go fishing and catch as much as we did? Boy, what a time we had in those days! And to think, we got paid for it, too! Wow! Now *that* was something that any kid would have loved to be a part of and we were living it.

One story our father told us happened sometime in the middle '40s, around 1944 or '45. It seems that my dad and a fishing friend were haul-seining along the shores of South Island or somewhere near there and had just made a big catch and needed to bring them ashore. Since World War II was still going on, the military had patrols going on along the eastern coast of the country. Well, as fate would have it, a commander had his troops out on patrol, but liked to stay hidden in the woods along the shore.

They wanted to go unnoticed and unseen, and that's just what they did. My dad could hear them; what with the use of Jeeps, trucks and such, it was easy to hear the motors. The patrol just happened to be in the woods along the shore where my father was haul-seining.

The patrol watched for a while and the lieutenant in charge of the patrol got curious as to what they were doing and came out from the cover of the woods to investigate. He wanted to make sure that there was no German or military operation going on that he didn't know about. Approaching with his men, they had their guns drawn and pointing at these fishermen! They inquired as to what my father was doing. Our dad told them that they were simply local fishermen out for a day's catch. The lieutenant didn't know anything about this and held my father and his friend on the beach while he sent word back to his commander as to what to do. Our dad simply stopped what he was doing and waited on the beach with these men. Once the commander arrived and saw that it was Hucksie, he began to chew out the lieutenant. Hucksie stepped in and told the commander, "Now, now, no harm has been done. These men were simply doing their job. Can't put a man down for that."

Since they had such a large catch that they were trying to bring in, the commander told his lieutenant to call the rest of his troops to come out of the woods to give these men a hand. As ordered, they came out of the woods and gave our dad a hand in bringing this catch ashore. They landed the catch and helped load the boat my dad was using at the time. I am not sure just how large the catch was, but it was a big one, that is for sure, because it took those men most of the afternoon just to get the fish loaded. The men in the patrol said that they couldn't see how just two men could have done all that work by themselves, because the entire patrol was so worn out that they were laying all over the beach, totally exhausted. My dad would always laugh when he told this story.

Above: Hucksie at about ten years old at Clambank with his pet cat, circa 1918. *Courtesy of the author.*

Left: Hucksie standing on a Samson post on the bow of a boat, believed to be at Clambank in about 1918. A Samson post is a post mounted on the bow of a boat for tying ropes. *Courtesy of the author.*

A few weeks later, dad was out fishing again along this same stretch of beach, making another haul. They could hear the patrol going on in the surrounding woods, but guess what? Those patrols would never come out of those woods again. My dad said that they could hear them on patrols from time to time but never saw one of them. No sir, not one of those men ever came out of those woods to give them a hand. They couldn't take that hard work and wanted nothing more to do with it!

A Commission, Maybe, But Not for Hucksie

During World War II, the U.S. Coast Guard offered our dad a commission to patrol the South Carolina coastline in search of any type of suspicious boat activity, enemy vessels or submarines. It was widely known that few men possessed his knowledge of the islands, inlets, creeks and coves of the Carolina coast and the Coast Guard was in desperate need of a man of his caliber. Hucksie was willing to take the commission, but it had to be on his own terms. Taking orders from the Coast Guard did not sit well with him; he was not used to taking orders from anyone, and the Coast Guard was no different.

The Coast Guard readily informed him that for him to come and work for them, it would have to be 100 percent their way and on their terms or else they could not use his services. Well, Hucksie turned them down flat.

Many who knew Hucksie felt he had walked away from a golden opportunity. As it is well known, he would have performed brilliantly in their services—if they had allowed him to have his way. He would have done the Coast Guard and his country proud. With or without a commission, he would have been acutely aware of any suspicious activity and acted accordingly. He could always handle the unexpected without batting an eye.

One such story is told of him being caught in a furious storm late one evening just offshore of the lighthouse off Winyah Bay. The story goes that Hucksie was heading into Georgetown in a twenty-eight-foot Seabrite skiff equipped with an old Buick engine that was barely running. He had spotted a U.S. Corps of Engineers' eighty-foot vessel and noticed that it was disabled and being blown out to sea. He quickly gave chase and was successful in hooking a towline to this much larger vessel and began to give tow. However, the old Buick engine just didn't have the power to pull them inshore. For over twenty hours they battled the storm and he was able

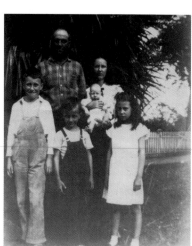

The Caines family in 1948. *Left to right*: Harrell, Hucksie in rear, Billy, me (as a baby), Veona and Carol. *Photo by Lester Lawimore*.

to keep that old engine running the entire time, preventing them from being blown out to sea. The engineers passed him gasoline by rope so he could keep the engine running, as his gas was running out. They later put a man on board with Hucksie so he could get some much-needed rest. It is said that he rested for only an hour or so and then was right back at the wheel.

When the storm subsided, the little Buick engine was able to take a stronghold and could make headway. Slowly the eighty-foot vessel was pulled into Georgetown. This kind of quick response to another's need was typical of Hucksie and he never hesitated to offer his help to anyone in peril.

HIDING IN PLAIN SIGHT

With all the duck hunting that had been going on, over time the ducks started to become somewhat scarce, to the point that the government had to step in and put regulations on the taking of ducks. It was made into a recreational sport and a limit was put on the number you could bring in. There was to be no more commercial taking of the ducks. You see, Hucksie had been hunting and selling ducks for a living for most of his life, up until this time when regulations were enforced. Well, that wasn't going to stop old Hucksie, no sir! He went right on hunting just like he had always done.

One morning, he and a friend went hunting for ducks to earn some cash. They had a great day and brought down a boatload of ducks. They had the ducks in their open skiff and only had a small outboard motor to propel them through the water. Hucksie knew and was friends with the local game warden. On this particular day, the game warden had staked himself at the mouth of the Sampit River leading into Georgetown, where he could stop the hunters as they were coming in and check out the number of ducks each boat was bringing in. Those who were in violation of the count received a ticket and had all of their ducks taken away. The warden had a large and fast boat and could run down most any boat that would try to run, which a few did, but to no avail.

Well, on this particular day they were heading in, putt putting along with about four hundred ducks in their boat. As they approached the mouth of the Sampit River, Hucksie spotted the warden and knew what he was there for and wanted no part of it. The amount of ducks they had would bring a sizeable amount of money in those days and he didn't want to give up his take. He knew he couldn't outrun the warden's boat with its fast motor, so he told the friend with him, "I'm going to pull a fast one, just sit there and act like nothing is wrong." They started heading straight for the warden's boat, and as luck would have it another hunter who was also heading in saw the warden and turned and took off in the opposite direction. Assuming the runaway was over the limit, the warden took off after him. As Hucksie's boat approached the warden's boat, Hucksie waved and the warden

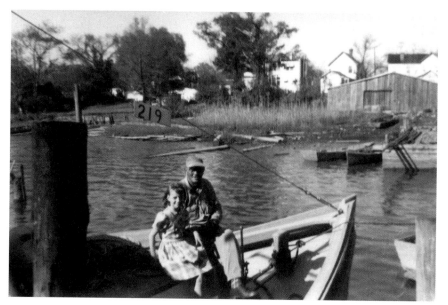

Hucksie with his daughter, Patricia, on the bow of the *Joey C.*, a shrimp boat our dad ran for Rene Cathou, circa 1959. *Photo by Carol Caines.*

waved back and shouted out, "Can't talk now Hucksie, gotta go check this one out!" The warden took off and went straight after the other boat, and my dad proceeded on in and was able to sell all of his ducks. He said, "It's no use to run when you know you can't get away, so take your medicine like a man."

He had planned to go right up to the warden and simply talk to him as if nothing was wrong, and hopefully be able to come in with his take. Well, luck was shinning on him that day, as he hid in plain sight! They sold all of the ducks and made a good profit!

A Mouth-watering Pilau!

Herman Waddell, a friend and partner of Hucksie's at the time, ran a fish market in town and had Hucksie supplying him with fish. Sometimes Herman would take supplies down the bay to Hucksie and his helper, Frank Smalls. On one particular occasion a few weeks before the start of duck-hunting season, it was necessary for Herman to take some supplies down the bay to Hucksie. Herman knew where to find Hucksie and Frank, as they always met in the same creek when he would bring supplies. Hucksie and Frank were getting hungry, as their supplies were running low. They decided that a duck pilau was in order. When Herman found them, they had already shot two pairs of ducks that were, in fact, taken out of season. They had found some ducks in a small inlet and were experiencing a mouth-watering desire for duck pilau that proved irresistible.

The game warden knew Hucksie was out there and knew he was famous for tactics such as hunting out of season. Each would contemplate what the other would do, Hucksie not wanting to get caught and the warden wanting to catch him. It seemed that Hucksie always stayed one step ahead of the warden and was not one to be caught. The warden took his boat and slipped into a small inlet where he knew Hucksie would most likely come after he had gathered his kill. He wanted to catch him red-handed. Well, Hucksie had his own plans.

When Herman came out, Hucksie tied his skiff alongside Herman's skiff and they pulled the two boats into a small cove that was totally hidden from view by tall marsh grass. They knew the warden had no idea that this place existed. Frank fired up the old Coleman stove, got out the black pot and in record time all three were enjoying the best duck pilau they had ever eaten. The warden never did find them, but claimed later that he could smell the pilau cooking and knew they were out there somewhere. After smelling the pilau for a little while, he decided to call it quits and head in. He himself was too hungry to stay out there and had to head in to get something to eat—chicken pilau sounded good.

A Short Ghost Story

One time, Hucksie and two of his friends, Henry Leonard and Cuffy Green, an African American gentlemen, were out on a fishing trip in Bulls Bay, right off McClellanville at the Cape Romain shoals. After a full day's work of fishing, they started in and realized that there was no way that they could get back to Georgetown before dark. They decided to put in at the old Cape Romain lighthouse, which was in ruins at the time and still is today. They put ashore at this particular place because there were three houses still standing, with one of them in pretty good shape. This was a good place to spend the night and have shelter from the elements. When they landed the boat ashore, old Henry Leonard started teasing Cuffy that the place was rumored to be haunted. Of course, Cuffy didn't like anything to do with ghosts or hauntings and Henry knew this. The place was rundown and without any lights, except for the lanterns they had brought with them. There were three houses and the third was the one still in the best of shape, so they decided to stay in that one. Well, it was also the one that was farthest from the boat. So they took their camping material up to this house and set up to cook some supper and spend the night. They had more stuff than they could carry in one trip from the boat, so Henry stayed behind to start things up for cooking their meal while Hucksie and Cuffy went back to the boat to retrieve the rest of the camping stuff.

As they started back and were passing the first house, Cuffy heard a sound that was something like the sound of a grunting hog. "What's that?" Cuffy asked Hucksie. Hucksie told him, "I didn't hear anything." As they started on up the little trail, again came the sound, but this time it was louder. Cuffy looked at Hucksie and

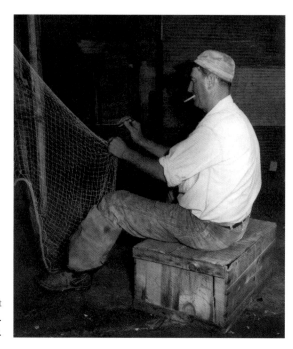

Hucksie behind his fish market
mending a cast net, circa 1965.
Courtesy of the author.

asked, "Did you hear that this time?" Hucksie told him, "Yea, I sure did, I heard something that time!" They stopped where they were and Hucksie looked around and said, "I don't know what that is, but I'm going to find out." Cuffy quickly told him, "This place is haunted and you had better not go in there! I'm not even sure I want to stay here tonight!" Hucksie told him, "Ah, this place is not haunted, come on and let's go on up to the camp. I'll find out what that sound is later, but don't worry, I'm sure it's nothing." Of course, Cuffy wouldn't go. Just then, they heard the noise again and Hucksie started toward the first house where the sound was coming from. Just then, both men heard a very loud laughing sound coming from the house. It was Henry, laughing as hard as he could.

Hucksie thought it was funny too, and burst out laughing, but Cuffy didn't find it funny and wanted nothing more to do with that place! Hucksie talked him into staying the night inside the third house, telling him that there was no ghost and the place was not haunted. Well, Cuffy stayed up most of the night, keeping watch with a double-barrel shotgun across his lap. The next morning they headed back to Georgetown and told the story about Cuffy and his adventure with the ghost at the old Cape Romain lighthouse.

The Ghost of Hagleys Landing

Once Hucksie and a friend, Frank Smalls, were fishing for sturgeon up the Waccamaw River, just off from Pawleys Island at a place called Hagleys Landing.

This landing was owned by one of Hucksie's friends, who had given him permission to use the landing so they could drive over from Georgetown to fish out the nets. Otherwise, they would have to make the trip by water and this would have been a long trip each day. By using the landing, they could drive over from Georgetown and save over an hour's worth of time.

Each day they would go and check the nets for any catch at slack water, when the river would slow down to a crawl, making fishing the nets much easier. This meant they arrived at the landing each day a little later than the day before, as the slack water is about an hour different each day and always later.

On one particular day in the late evening, they were at the landing and, having just gotten back from fishing the nets, they were both down by the little dock where they kept the skiff tied up. They were taking fish out of the boat and placing them into the back of Hucksie's truck when they both observed a man walking down the road that led to the landing. They didn't really pay him any attention, but kept an eye on him just the same.

About 150 feet from the landing was a little house that they called the camp. The man came right on down the road until he was just off from the little camp and turned and went up to the camp and disappeared inside. Hucksie told his striker, Frank, "This man must have come down here looking to buy some fish, I'll go see what he wants." Well, Hucksie went up to the camp and called out to the man who was inside, "Hey! Can I help you?" He got no answer. He called out again and once again got no answer. So he went inside to see what this man was doing. When he entered, there was no one there. It was only a one-room camp that had one window in the back, which was still locked from the inside. Hucksie thought to himself, "This is strange."

He went back outside and looked around, then went behind the camp, but could find no one. He returned to the boat and told Frank, "I couldn't find anyone up there. You did see a man come down the road and go in the camp, didn't you?" Of course Frank had seen the man and told Hucksie, "I sure did." They both thought that was strange but dismissed it and went back to work.

The next day, Hucksie was telling the owner of the place about this man they had seen. Much to Hucksie's surprise, the owner told him of a similar story that had happened a few days earlier. The same man was seen at his plantation home and just like Hucksie's story, this man came down the road and went into one of his tool sheds. They went to see what the man wanted, but they could not find anyone. Just like Hucksie, they looked all around the place, but no one was to be found. Hucksie began telling the owner what the man they saw was wearing. He had on tan slacks and a light green shirt and was wearing a baseball cap. The owner told him that was just what the man they had seen was wearing. No one ever found out who this man was or what he wanted, as he could never be found.

Later, they both heard that this man had been seen by quite a few other people and always with the same story. He would come down the road, go into some small house, tool shed or something like that, and then he couldn't be found anywhere. Hucksie and Frank just called him the Ghost of Hagleys Landing!

OTHER TIDBITS ABOUT HUCKSIE

Once, while on a hunting trip, a wild boar suddenly came charging out of the thickets with his mouth wide open straight at Hucksie. Well, ol' Hucksie just happened to be carrying his single-shot twelve-gauge shotgun; the only problem was, it was empty. Not much good like that. As the boar charged with its mouth wide open, Hucksie brought up the gun with the intention of ramming it down the boar's throat. Just as the boar came in range of the barrel, the boar turned his head and the gun barrel entered his ear. Hucksie kept pushing the gun at the boar and managed to keep the barrel in the boar's ear and around and around they went. With the barrel lodged in the ear of the boar, Hucksie was desperately attempting to load a shell into the shotgun. It must have been a sight to see.

Hucksie finally managed to get the shell into the barrel, cock the gun and pull the trigger, which blew the boar's head clean off, with his brains exploding in all directions. The boar was quickly dressed out and they had fresh pork for several weeks. It should be stated that Hucksie never hunted for sport or killed needlessly or excessively. He hunted for food, whether for himself or to sell to others, but food just the same.

Hucksie's colorful life was not without its pleasure. There was a magazine in Columbia that was doing a story about the Georgetown-area sports fishing. They wanted a picture of a sportsman with their model, a young pretty thing, for the story. Hucksie was selected to take the South Carolina beauty queen on a fishing excursion out in the ocean aboard a yacht he was the skipper of at the time. The photographer snapped an excellent picture of Hucksie and the model in the stern of the yacht, with Hucksie holding a large spot-tail bass on a grafting hook. The picture made the cover of the well-known newspaper *The State*. It is thought to be one of the best pictures ever made of Hucksie. We still have a copy of this picture, framed and hanging in our home.

Hucksie and Henry Leonard not only fished together, but they were also hunting buddies. They always had a very special relationship and were the best of friends. When we lived on Front Street in town, Henry lived on the same block, behind us on Prince Street. We could cut through the middle of the block to Henry's house. Our dad would send us over to Henry's from time to time, whenever he needed him.

One of Henry's feats was his ability to walk catlike around the rail of an open skiff and never fall or rock for balance. He was a short, stocky man with powerful shoulders and arms like pile drivers and he was strong as an ox. Hucksie and Henry

Hucks Caines Jr.: His Life and Times

Clarence Cherry and Henry Leonard on the Oak Hill Drift about 1975. *Courtesy of the author.*

were famous for hunting alligators together. They could bring in a truckload from a single night's hunt. They hunted the gators for the hides and sold the meat locally, as alligator meat can be very tasty.

One night they were hunting for gator and shot an eleven footer. Unknown to them, the bullet had only grazed the gator's head and knocked it out. Henry said the size of this one alligator nearly whipped both of them, trying to land it into the skiff. Once they got the gator in the skiff, they were heading down the river, when suddenly they discovered the gator was very much alive and he was fighting mad. Henry still had a hold of his rifle and a quick blow to the head with the rifle butt took care of the situation. On more than one occasion, they have had a gator come back to life, as you really never know for sure that a gator is dead. "You have to always keep an eye on them," Henry has stated.

On another hunting trip for gator, they had several in the boat and one of them began to move about. It appeared that once again a gator had only been stunned. Henry had a hatchet and swung it at the gator's head. The gator moved to the side with a quick snap and Henry missed. Henry had chopped a huge hole into the bottom of the skiff and it began to fill with water. Another quick blow with the hatchet took care of the gator, but the hole was still there and the boat was starting to sink. Fortunately, they were in shallow water and they quickly turned the boat and landed it up onshore. Hucksie took an old rag, laid it over a piece of scrap wood and nailed it to the bottom of the boat and with the rag acting as a gasket, they were able to make it back to the landing. They were also able to save their catch.

Drawing of an alligator. *Courtesy of the author.*

Whenever Hucksie and Henry had a successful hunting trip, they loved to go on a drinking binge. Old Hucksie could be mean and argumentative when he was drunk. Henry knew this all too well. Hucksie could out slug Henry because of his height and the reach of his long arms. Henry was more like a wrestler and when they were fighting, Henry would maneuver until he could use his powerful arms and shoulders to grab Hucksie around the neck in a hammerlock, bringing him into submission. This was always Henry's best defense when arguments surfaced. He would refuse to release his hold until Hucksie promised to behave. It is said that Henry was the only man ever to be able to do that to Hucksie. They were the best of friends and remained friends for as long as they both lived.

When we purchased our present home in Georgetown County, it wasn't long before Henry also moved and as luck would have it, he moved onto a lot right behind our home, on the property right next to ours. He lived just a shout away. We always thought that was neat.

A LIFE-CHANGING EXPERIENCE

One afternoon, while Hucksie was standing on the dock out behind the fish market, he had what would prove to be a life-changing experience. He had just brought in a good catch of fish and was feeling good about it; he had already purchased his first bottle and was getting ready to tie one on. He was standing on the dock and happened to look up into the sky and saw some clouds passing by, when suddenly the clouds parted, revealing the face of the Lord. He said he could see it as plain as day. He called out to Veona, his wife, to come out of the market and see this sight. She looked up and saw nothing but the clouds. Then Hucksie asked the vision to show more of itself, asking, "Show more of yourself, so Veona can see, too." And the vision appeared to its waist and Hucksie said, "There, can you see Him now?" Veona could not see anything, only the clouds. As he looked up, the clouds closed together and the vision was gone.

Hucksie realized instantly that he had been given the rare privilege to view the Lord and to gaze beyond the heavens, where few have seen. The effect on Hucksie was dramatic. Shaken and unnerved, deep down from within, where the heart reigns and the mind stops rationalizing, he felt a wonderful change come over him. The effect was profound and lasting. He swiftly and decisively tossed the unopened

Hucks Caines Jr.: His Life and Times

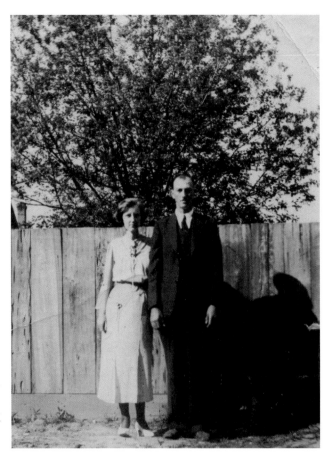

Joseph and Veona on their wedding day, behind Ruby Caines Fitts's home on Hazard Street in Georgetown, South Carolina, circa April 1936. *Courtesy of the author.*

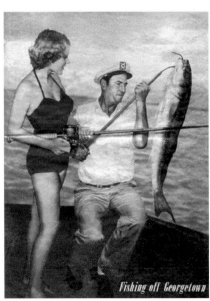

Cover from *The State*, Columbia, South Carolina, August 17, 1952. "Georgetown is fast developing into one of the most famous deep-sea fishing points along the South Atlantic coast. The center of attention aboard the fishing boat on today's cover is a 37-pound channel bass that has been brought to gaff. Or is it? Miss Jeannette Bostick and Capt. Hucks Caines of Georgetown are admiring the catch." *Photo by Stan Lewis.*

The house on Hobcaw Barony where Hucks and Ida Caines lived and Hucksie was born. *Photographer unknown.*

Above: Ida Viola McCormick Caines, Hucks Caines's wife. *Courtesy of the author. Right:* Joseph Jenkins Hucks Caines Sr. *Courtesy of the author.*

bottle into the river and he never drank again. At long last, alcohol no longer controlled him. He was a changed man, changed for the better.

Hucksie was a man who was cast in an unparalleled mold, a man who was truly one of a kind. He was a free spirit embodied with the skill and sensitivity of a fisherman and the true eye and steady hand of a hunter—a brave man, a God-fearing man, a man at ease on the wide river, in the dense woodlands or on the wide-open sea. A tall, strong man who proudly wore his daring, robust heritage, a heritage instinctively passed on to him by his forefathers. He was an honest man who paid his debts. He was afraid of no man. He busted his way bare fisted out of many a bloody fight. It was said that hitting Hucksie was like hitting a solid steel telephone pole. God help you if you got in his way when he was in a drunken state. His drunken binges were often triggered when the shrimp weren't running or the fish weren't biting. After all, this was his livelihood and he worried about supporting his family.

The years add up and in time, the body gives way. The axe split wide the trunk of the tree and Hucksie was felled by a stroke. His once strong legs became immobile and he got about in a nursing home wheelchair. The free spirit, the renegade no longer roamed his beloved woodlands or would feel the soft salt spray on the side of his face. Over the next few years, his condition slowly worsened and time caught up with him. He passed away on August 26, 1977. He was sixty-nine years old.

He had lived a rough life and could be hard as nails. Yet beneath all that gator-hide toughness was a quiet, easygoing, likeable man. He always knew he had a loving, praying mother and her prayers had followed him all the days of his life.

Hucksie was a legacy within himself and transmitted his love for the river, the sea and a hard life to two of his sons, Roy and me. Part of him will always live in his descendants, but there will never, ever be another Hucksie.

Chapter 4

Jerry and Roy

The Early Years

When we weren't out fishing with our dad, we worked at our parents' fish market. Did I say work? We were supposed to be there working, cleaning fish and such for our customers. But most of the time we were out in the river playing in our little boats. We had sailboats, motorboats and rowboats. Most of the boats belonged to our dad, but we treated them like they were ours. We were always doing something in that river, in those boats.

Our Sailboats

For me, my first love was sailboats. In fact, a couple of friends of mine, Wesley and Randy Young, and I built our own sailboats. They were more dinghies than boats, but they were all ours. We each had our own, three sailboats in all. They averaged ten feet in length and were about six feet wide. I named my little sailboat the *Mermaid*.

I was about fourteen or fifteen years old at that time. How in the world did kids of that age have money to build such a boat? It was easy. We simply saved our school lunch money and did not eat lunch. We saved it up until we had enough to purchase one board, one simple plank that measured eight inches wide by twelve feet long. This went on for a board or two per week. This also went on for each boat that we built. In time, the boats were completed, one board at a time. The wood was cheap in those days, so it didn't take all that long to buy two or three boards. Guess what? It only takes four boards to make the sides and four to make the bottom of each boat. Of course, we added seats, a rudder, a centerboard and a centerboard tank; these are things a sailboat needs. A centerboard keeps the boat from sliding sideways in the water while under sail. Plus, we added a mast, nothing more than a two by two, sixteen feet long. For stays, we found old electrical street wires that had been tossed out.

Jerry and Roy: The Early Years

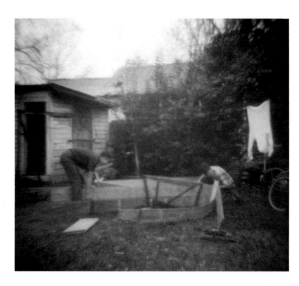

Me and Wesley Young constructing one of our sailboats, April 1967. *Photo by Randy Young.*

These street wires made great stays to hold up our mast. There was a boom that ran out about eight or nine feet. These little boats sailed remarkably well, much better than we had expected. We got the plans from a book from the school library, modified them to suit our own needs and bingo, we had our sailboats.

We spent a lot of time in the Sampit River, which runs right through the middle of Georgetown. Our fish market was right on the riverfront and in the center of town, on Front Street at the foot of Orange Street. People up and down the street could always hear our mother calling us to come in and help her clean some fish or some other chore she had for us to perform. She only called us when there was more than she could handle by herself.

We would come running whenever she called, that is, when we were close enough to hear her. Got fussed at quite a few times, more times than I care to remember, but hey, those were the days.

There was an old plant on the river about a half-mile from our fish market that had been closed down for quite a few years. We called it the veneer plant, which is what it used to be. We would sail our boats down the river to that old plant and put in on shore and explore all over that place. We found a big pile of old lumber, old boards in all kinds of shape. Some rotten beyond use, but quite a bit of it was still in fairly good shape, good enough for us. What could we boys do with lumber like this? I'll tell you, we built a nice little clubhouse. It was built right on the river, right next to the fish market. It was behind a drugstore where we bought candy bars and sodas. We knew the owners quite well, and they gave us permission to build our clubhouse on their property. We also built a small dock out over the river, where we tied up our boats. This was right next to our parents' fish market, which was great for us. This way, we were right there whenever our mother needed us in the market for things like cleaning fish for customers or packing fish in ice.

My sailboat, the
Mermaid, in 1967.
Courtesy of the author.

Anyway, back to our clubhouse and our sailing adventures. The clubhouse was our general headquarters where we hung out. There were three of us in my group that consisted of myself, Wesley and Randy Young. We were like the generals of our group. Then there was Roy, my brother, and his friend Peter Poit, whom we all called Petey. Now Petey was quite the character. I mean he was very funny, always doing something silly and crazy. One such story with Petey occurred one windy March day. I let Petey borrow my sailboat to take a little sail across the river. Petey was not all that experienced at sailing and I knew this and against my better judgment, I let him take the *Mermaid* out for a sail in those windy conditions anyway.

Both Roy and I were standing on the dock watching Petey try his hand at sailing. He left the dock quite well, went across the river, came about and sailed back across the river, straight at us standing on the dock. He did well for a little while. Came right up to us on the dock. He then made a quick come about, performing what is known in sailing terms as a jib. This means that you come about, turn the boat around and the wind will take the boom and whisk it across the boat from one side to the other. The correct way to do this would have been to take the bow up into the wind, where the boom and sail would come across the boat in a more controlled manner, like a flag waving in the wind. Only Petey didn't do this, no sir, not him, with Petey being Petey, instead he made a jib and he was standing up at the time. Once the wind caught the backside of the sail, the boom and sail came switching across the boat and caught Petey just behind the legs and almost knocked him out of the boat. With his back to the sail, he quickly grabbed the rail of the boat in a bent over position. With the sail and boom up against him, about to push him out of the boat, all he could do at that moment was hang on. The wind caught second gear, a strong gust came up at that exact moment and with the boom not able to

Jerry and Roy: The Early Years

Above: Petey behind the fish market showing off his muscles. I can be seen in the background, circa 1969. *Left:* Wesley Young, me and Randy Young, April 1967. *Photos by Roy Caines.*

come across the boat, as it was being held by Petey, the boat took off with great speed, The boat heeled over on one side and both Roy and I could see half of the bottom of the boat. The centerboard was coming up out of the water and we just knew Petey was about to get wet, as we thought the boat was going to turn over. Well, what happened next made Roy and I start laughing so hard that if Petey was drowning, we wouldn't have been able to help him.

The mast is held up by three stays. The electrical wire that we used for stays was held to the rail of the boat by simple screw hooks, like the ones you use to screw into a wall to hang a hat on, which aren't very strong. The hook that was on the starboard rail, the right side of the boat, straightened out under this tremendous wind and with the boat up on its side and moving at a great speed, the hook gave way and the mast came crashing down and the sail covered Petey completely and the boat came smashing back down and made a tremendous splash.

We could see Petey's outline under the sail and he was swinging his arms all about. The sail was jumping and swinging with Petey's movement. To hear him, a very young boy, cursing and raising hell with all that commotion, Roy and I were laughing so hard that we fell on the dock and rolled around. This was one of the funniest things we had ever seen, a real highlight of our young lives.

Petey apologized for bringing down my mast, but hey, I told him accidents do happen and for what we saw, it was well worth it. We talked and laughed for weeks about that incident. It was truly a moment to remember.

Wesley, Randy and I started a thing that we liked to call the water fights. We would take the three boats out, each one loaded with water balloons and a bucket or two. Roy would go with me and Petey would go with Wesley or Randy. Under sail, we would pass by each other and throw water balloons, trying to wet each other.

Petey in the foreground, with Randy sitting and Anthony Hyman looking on. Roy can be seen just behind Petey. This is behind our fish market in the summer of 1967. *Courtesy of the author.*

When the balloons ran out, we used the buckets to scoop up water and throw it at each other as we passed. We would all get soaking wet, but we had a ball doing this. Sometimes we did this on the docks, running up and down the docks behind the stores on Front Street, throwing water balloons at each other. Sometimes we had teams and sometimes it would be each man for himself. Those were the water fight days.

THE WOOD PIRATES

Petey was always up to some mischief. He was like our scavenger and could always find whatever we needed. One time we needed more wood to complete our dock. But the needed wood was in short supply for us. One Saturday afternoon, Petey came running down the dock with a handful of boards that he claimed he found in a scrap pile that had been tossed out. He told us there was a whole stack of this wood and we could get it for our dock. So we all went with him to see this great pile of lumber he had found. We ran down the dock from our fish market toward the town clock. It was right there behind the town clock that we found it, a large pile of wood, just lying there, like Petey had said. No one was around, so we figured it was tossed out old wood. There were boards of all sizes and shapes. In fact, there was so much wood that we couldn't carry it all back by hand. We decided to go back to our clubhouse and get the boats and use them to bring this pile of old lumber back to our dock.

Now, here's the real deal with the free lumber. Unknown to us, the wood belonged to another group of schoolmates who were sort of like our rivals on the water. They

Jerry and Roy: The Early Years

Petey Poit at our dock with the steel mill in the background, circa 1969. *Photo by Roy Caines.*

had gotten the lumber to build a dock for their little boats, right behind the town clock. They lived about two city blocks from the town clock and were using their bicycles to bring their lumber down to the river. They placed the boards lengthwise across the handlebars and seat so they could push the bikes and carry the wood to build their dock. They couldn't carry all the wood in one trip and were making several trips back and forth. While they were away, Petey had grabbed the first load of wood that he brought to our dock.

Upon returning with the boats, there was more wood there, much to our surprise. We looked around and could find no one. So we commenced to load up our boats with the free wood. The other guys had returned to their home to get more wood while we were there. With our boats, we were able to collect all of the wood. We left their site and returned to our dock and unloaded the wood. We started right away, nailing the boards to our dock where they were needed. A little while later, we decided to go and see if there was any more wood tossed out. Instead of taking the boats, we decided to walk down the dock. About halfway in our trip, we ran into the other boys coming down the dock. They were looking for their wood!

We stopped and they stopped. We were facing each other and the confrontation began. They informed us that they were looking for their wood. We defended ourselves and claimed we hadn't taken their wood. Randy asked Petey if the wood he had found had come from their site. Since Randy wasn't with us at the time we got the wood, he wanted to make sure Petey hadn't taken their wood. Petey, being Petey, stated that he had found the wood behind one of the stores and not at their site. We argued for a little while, claiming that the wood that Petey had found was not theirs. Randy turned to Petey and asked again, "Are you sure you didn't take

Roy tying up the *Chris Boat* in front of our clubhouse at our dock, June 1969. *Photo by Petey Poit.*

their wood?" Petey stated, "No, it's not their wood I found, it came from another place, so it's definitely not theirs." They wanted to come to our dock and see for themselves, but we wouldn't let them pass, stating that just because they saw wood on our dock, that in no way proved that it was theirs. They could just claim it and that wasn't going to happen! Since Petey claimed it was not their wood, we were going to keep what he had found!

Of course, Wesley and I knew exactly where the wood had came from, but we didn't say a word; we were on Petey's side. Besides, we were like the pirates of the waterfront and this just played right into our hands and added to our reputation as scoundrels of the waterfront. The confrontations ended and we both returned to our own docks. When we got back, Randy asked Petey if he had really gotten the wood from their dock. Petey simply said, "Yea man son, weeeee," which was one of our sayings in those days. Randy got really mad at Petey, which was also common in those days, but decided we would keep the wood anyway. After all, Randy was a pirate, too.

A little later that afternoon, Petey came running down the dock, a handful of boards in his hands and three or four boys in hot pursuit. Petey was yelling, "Help, help, I'm about to get beat up, help!" Of course, we all came running out of the clubhouse to see what all the commotion was and right away got between Petey and the same group of boys we had argued with before. Once again, another confrontation began, only this time we did the right thing. Randy asked Petey if he had gotten the wood from their dock. This time Petey said, "Yea man son, weeeee," so we made Petey give the boys back their wood. After they left, we asked Petey how

Jerry and Roy: The Early Years

Roy in front of our clubhouse, June 1969. Our dock can be seen just to the left of Roy. *Photo by Petey Poit.*

he had gotten the wood. He told us that he went down there and stayed out of sight and waited for them to leave. They had left no wood lying around, so he tore it off their new dock. He used their own tools, a crowbar and hammer, to tear it off their dock, about four or five boards. He was getting ready to return to our dock when they reappeared with more wood. They had seen Petey this time and the chase was on.

It was in the late afternoon when we heard Petey coming down the dock once again, yelling to us in our clubhouse. As we came out of the clubhouse, we could see Petey coming down the dock once again with that same group of boys chasing him. We went running down the dock toward him and the boys who were chasing him. Once again, we got between Petey and the group of boys. And once again, we had another confrontation. Randy asked Petey if the wood he was carrying was from their dock. As before, Petey lied. He told us he found the wood at another location and they were just trying to take it from him. He swore he had not taken the wood from their site. We defended Petey and wouldn't let them have the wood back, thinking it was wood Petey had found somewhere else. They stormed off and threatened they would get us back. Just how, they never said. We were always on our toes after that.

Of course, Randy found out that Petey had lied. Petey had actually torn it off their dock, using their own crowbar. Randy was really mad at Petey and all Petey could say was, "Yea man son, weeeee! Yea man son, weeeee! Yea man son, weeeee!"

We used the wood Petey had procured and put it on our dock. Petey was our scavenger and he was good at it. In fact, he was the best. Those poor fellows never did get their wood back and as far as we know, they never did anything to us or to our dock or clubhouse.

Barely seen, Petey is at the wheel of the local firetruck at the fire station, about 1967. *Photo by Roy Caines.*

Roy inside our clubhouse, June 1969. *Photo by Petey Poit.*

DOWN THE STREET WITH FIRETRUCKS

Roy and Petey had a great passion for firetrucks, much more than the rest of us. With our market just one city block from the fire station, we would all go down there from time to time to buy our soft drinks. The cost was only a nickel at that time at the fire station.

The friendly firemen at the station would let us play on the firetrucks. That was a real treat for us. We would ring the bell and pretend we were driving the truck on our way to a fire. Roy and Petey even played with little toy firetrucks, always pretending that they were driving to a fire. They had a ball doing this.

Roy and Petey would play firetruck with their bicycles on Front Street. At the entrance of any store on Front Street that they might happen to choose that day, they would back their bicycles into the little hallway that led to the store's front door, which also happened to resemble the front of the firehouse. They had little battery-operated sirens mounted on their handlebars and would sound the siren just like the firemen did before pulling out of the station on their way to a fire.

Roy and Petey would come rolling out of the little hallway in front of the store, sirens blasting, and ride as hard as they could down the street and around a corner and disappear from sight, only to come back moments later and perform the whole scenario all over again. This could go on all afternoon.

Roy always stated, "When I grow up, I want to be a fireman or a fisherman." As he got older, the fireman dream was put aside and the fisherman was realized.

Chapter 5

The Glory Days
Our Fishing Adventures

After high school, I joined the navy in the spring of 1969 and signed up for a four-year tour. I went to Orlando, Florida, for my basic training. Right after boot camp, I was assigned to my first ship, the USS *Boston*, a heavy cruiser home ported out of Boston, Massachusetts. I was sent to a port of call in the Philippine Islands, where the ship was on leave from the firing line in Vietnam. Yep, I was headed for Vietnam. While I was in the navy, Roy stayed home to finish school and help out our parents. He worked at a hotel in Myrtle Beach, the Ocean Forest, during the summer months and this helped support the family. Of course, Patricia was still there too and worked to help support the family until she got married in 1971, at which time she moved out.

While I was in the navy, I did one tour of duty in Vietnam in the summer and fall of 1969 and received two medals while I was there, one for the Vietnam campaign and one for being in a combat zone. Our ship gave offshore support to the troops onshore. We didn't fire all the time, but only when support was needed, day or night. After Vietnam, the ship was headed to Boston, where it was to be decommissioned. The ship took a scenic route home by way of Hawaii and Mexico. We played in the sun and simply had a good time. While in Hawaii, I got to see the battleship *Arizona* and render honors to it. As we were leaving the harbor, everyone on board gave a hand salute in honor of those who lost their lives at Pearl Harbor.

The ship made a stop in Acapulco, Mexico. This was really a treat for me. I always wanted to see where the famous dive was made from the cliffs. I not only saw the cliffs, but as luck would have it, they were making dives the evening I was there. I couldn't believe how brave those men were. They would climb up the face of the cliffs, kneel before a small shrine and say a little prayer for a safe dive. They would stand up, turn and step up onto a diving platform and raise their arms high overhead. The crowd was cheering like crazy as these brave young men made those spectacular dives, right down through the narrow cliffs and into the water below. This was one of the most exciting things I have ever seen.

The Glory Days: Our Fishing Adventures

Top: The heavy cruiser USS *Boston*, as we passed through the Panama Canal in the fall of 1969. *Middle:* The destroyer tender USS *Cascade*, my second ship while in the navy. I was on her for two years. This is where we set at anchor to tend to ships as needed. My job was to run personnel to and from shore. I ran a fifty footer and later the officer's motorboat. March 1971. *Left:* The USS *Cascade* while underway in the Mediterranean Sea, 1971. *Photos courtesy of the author.*

We spent three days in Acapulco and headed south and went through the Panama Canal into the Gulf of Mexico. This was something that I thought would never happen to me. I remember studying this in school, but never in my wildest dreams thought I might one day actually go through the canal. It truly was exciting.

After that adventure, I made two trips to the Mediterranean, one on a destroyer tender—the USS *Cascade*—and one on the super carrier USS *Forestal*. I ran boats, or motor launches as they are called in the navy. I would bring supplies for the ship and also run personnel back and forth to shore. This is what I enjoyed doing.

When I was discharged from the navy in 1973, I was in Philadelphia, Pennsylvania, where I saw the USS *Boston* once again, my first ship, as it was now on display for tourists on the navy base. I always thought this was neat, because I had come full circle, from this being my first ship and now the last ship I saw as I departed the navy.

Once home again, I decided to work with Roy and take up our father's trade as a commercial fisherman. We used the money I had saved up while in the navy to build a small boat and get an outboard motor. This started us in business.

Since I had been discharged from the navy in May of 1973, we started shrimping later that year. We did fair during the summer months. Since Roy was still in school, his senior year 1973–74, we didn't shrimp much that fall. Roy graduated the following spring and that's when our real fishing adventures began.

We shrimped during the summer and fall months of each year. After that, we would shad fish in February and March. As shad season would come to a close, we started sturgeon fishing. We would sturgeon fish for their caviar. Of course, we also sold the meat, which was shipped to New York by way of truck through the Cathou Fish House. We always did our selling and business through Rene Cathou's Fish House. This is also where our father had done business when he sold outside of his own fish market. Rene Cathou was always good to us, I think because he really liked us and because he and our father were always good friends.

It seemed that every time we were not doing very well in a season, Rene always had some sort of work for us. He would have us repairing the fish house dock, the floors in the fish house or working at his home, fixing a board on the front porch or painting his house. He always had something to keep us going. In January through the '70s and '80s we would mend his stake-row nets and patch up all the holes, since we knew net mending. This always helped us get through the winter months.

Shad Fishing

Shad season lasts only two months a year, in February and March and sometimes extended into April. It always ends on the Saturday before Easter. The season opens each week on Monday at noon and runs for the week until Saturday at noon, at

Top: The USS *Forestal* CVA 59, my third ship while in the navy. I was on her from June 1972 through June 1973. *Middle:* The USS *Forestal* CVA 59 on a Mediterranean cruise in 1973. *Bottom:* The USS *Forestal* CVA 59 with an escort while in the Mediterranean Sea, about 1973. *Photos courtesy of the author.*

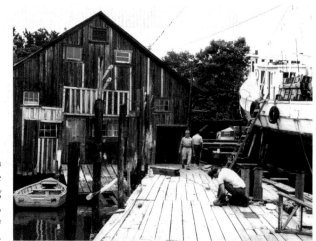

Rene's fish house with Rene coming down the dock and Roy making repairs on the dock, spring of 1981. *Courtesy of the author.*

Rene at his table saw in the back of the fish house, March 1981. *Courtesy of the author.*

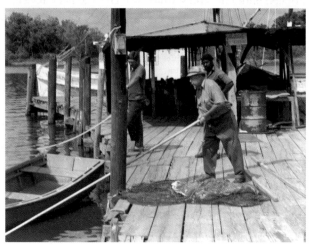

Rene Cathou putting a boat on the railway. Right behind Rene is his dockworker Sam, plus Anthony Hyman holding the stern line, June 1987. *Courtesy of the author.*

Roy Caines and Clarence Cherry hanging in a shad net. Note the cork (float) and ring opposite each other, to keep the net in balance, circa 1976. *Courtesy of the author.*

which time it closes again for the weekend. This gives the fish a couple of days to come in and lay their eggs. This will ensure next season's crop and perpetuate the species. It gives us a break, too, from the week of hard fishing.

We fished with what is called a drift net. You run it out of your boat and string it across the river or stream where you are fishing. The river current takes it and it drifts with the tide, whether it's going upstream or downstream. If it's going out—ebb tide—or if it is coming in—flood water—you just let the net go and drift along with it. We had what is called a ring net. This is where the net is hung in and sewn to a top line with corks to float it and metal rings on the bottom line to sink it. The rings are made of metal and are about six inches in diameter and they are tied under the corks, which will give the net balance in the water. Once the net is strung out across the water, it acts like a chain-link fence standing up and down in the path of the incoming shad. Once they run into the net, they become gilled, which is what gives us the name gill net. When the fish runs into the net, it can't move forward because it is too large to fit through the mesh, a diamond-shaped hole in the net, and the fish can't back up because the net gets caught behind its gill cover and stops it.

Roy fished from one boat while I fished from another. Our nets were about three hundred yards long and we put them out and took them up again, each by ourselves. Early on, we drifted in the Waccamaw River, just above the bridge coming into Georgetown. This drift was named the Oak Hill Drift. Just where it got that name, I can't say, but that is what we always called it. The drift is about five miles in length. We put out just below Butler Island and with a falling tide would drift down to the bridge, where we would take up the net. We would then run back

up the river to a spot we called the put out tree. It was a small tree out from the riverbank where we all tied up our boats to wait our turn to put out again. This kept order and fairness in the river for each fisherman. We weren't the only ones fishing there. We fished the Waccamaw for several years. In time, the river became so crowded with fishermen that you might get one or two drifts in a day. That's not good when you're trying to make a living. So we moved to the ocean to fish with anchor nets. They're made the same way a drift net is, except you can use a core-leaded line for the bottom line and the nets are anchored to the ocean floor on each end by heavy anchors.

We had five nets. Two of them were 200 yards long, two were 150 yards long and one short one was 120 yards long. We named this short net Baby Doll. It was always placed inshore because the shad run along the beaches to get to the inlets. It always out caught the other nets. We fished just outside of North Inlet and south of Pawleys Island, a place called Debordieu. Here we had some of the best seasons of our shad-fishing career.

After I got out of the navy, Roy and I shad fished together in the same boat and drifted our net in the Waccamaw River at the Oak Hill Drift. This was the winter and spring of 1974. When the river became overcrowded with fishermen, we moved to the ocean off Debordieu Beach and it was here we used our anchor nets.

We weren't the only ones fishing for shad off Debordieu. Another fisherman, Bobby Ackerman, also fished there and with a whole lot more nets. But hey, we were always small-time because we liked it that way. It wasn't so hard on us and besides, our boat was only so big, seventeen feet in length and with a wide beam of eight feet.

We would start out at about five o'clock each morning so we could arrive at the mouth of North Inlet at just about daybreak. We wanted to be able to see so we could make the run out of the bar. There is a channel that runs straight out and as long as you stayed in the channel, you wouldn't run the risk of hitting bottom and getting stuck. When the tide was high enough, you could cross the sandbar and run right up the beach, which saved us a lot of time and gas.

To fish the anchor nets, you would simply go to one end, pull up the bottom and the top lines and place them across the boat. With Roy on one end of the boat, usually in the stern, and me in the bow, we would pull the net across the boat and pick out the shad as they came up. We would pull and pick out fish until we reached the other end of the net. We made sure to cradle the net, so as the fish came up they would be pocketed between us and the net would hold them like a basket. If a fish fell out or came ungilled, the net would still be holding them and they wouldn't get away.

Just like the river fishing, we had to take up our nets on the weekends. They had to be out of the water before noon and we couldn't put them out again before noon on the following Monday. Once again, this was done to give the fish a fighting chance to come in and lay their eggs.

The Glory Days: Our Fishing Adventures

Top: Me in the bow of my wooden skiff, shad fishing on the Oak Hill Drift, circa 1980. *Photo by Roy Caines.*

Left: Clarence Cherry and Roy Caines shad fishing in 1975 on the Oak Hill Drift. *Courtesy of the author.*

Rene Y. Cathou always bought our fish and shipped them to distribution houses in New York and Pennsylvania. Captain Rene, as we called him, always looked after us, the fishermen that sold to him, which included Ronnie Campbell, Bobby Ackerman and ourselves. We were all known as His Boys. Whenever we would be late or overdue from coming in from one of our fishing trips, he would be the first one to alert the local rescue team or one of the other fishermen of the situation and send help for the overdue party.

One Monday morning, Roy and I were anchor net fishing for shad off Debordieu Beach. Being Monday, we couldn't put out our nets until noon. This part we always liked, because we didn't have to get up early. We hung around the fish house until almost noon before we left to put out our nets. It was spring and the weather was already turning hot. We knew it wouldn't take long to get the nets out and we would be back early, before three o'clock. It was such a lovely day that we decided to leave our coats in the truck at Rene's; this would prove to be a mistake. It was a sunny day with no wind and it didn't take long to get to the fishing grounds where we fished just off Debordieu Beach. Bobby had already left ahead of us and by the time we got there, he was about through putting out his nets. We fished our nets about a quarter to a half-mile apart from each other. This would give us all enough room. Bobby was fishing north of us and we were to the south and closer to North Inlet.

As soon as we got there, we started putting out all five of our nets. By the time we were starting to put out our third net we could see Bobby coming up the shore. He had already completed setting out his nets. As we were putting out the third net,

69

Bobby Ackerman with a load of shad at North Inlet during shad season, March 1983. *Courtesy of the author.*

a small wave slapped against the stern of the boat and caused the control handle to get wet. The key ignition is also on the control handle and when this got wet it shorted out the motor, which made it cut off. This was no big deal to us, as our motor seemed to cut off a lot but would always start up again. Well, Roy tried to start it, but it only spun over and wouldn't start. I was in the bow and holding onto the net. We only had about four or five corks out, about twenty yards of net. When the motor wouldn't start, I started to wave to Bobby as he was passing inshore of us. Like I said, we had two nets already out and we were at the location of the third net, which put us a good bit offshore. Bobby and his crew didn't see us waving and passed us by, headed for Georgetown.

Roy said, "Don't worry, brother, we'll get it started, you know I always do." Well, it didn't happen; it wouldn't start. Roy worked on it as I held on to the net, which we used as an anchor. After a while Roy still couldn't get the motor started and we decided to pull the net back into the boat. Once we got the net in, we left the anchor out to be anchored where we were. We knew Bobby had seen us and knew where we were, so it would be a good idea to just stay put right there. We couldn't go anywhere anyway, since the motor was dead.

Later that evening at the fish house, Rene asked Bobby if he had seen us. Bobby told him, "Sure, they were right there putting out their nets, where they always fished. Well, you know how those boys are, they are never in a hurry, never rush, put out their nets just right to suit them. Then, when on the way in, they'll stop on the

The Glory Days: Our Fishing Adventures

Petey Poit, Clarence Cherry, Ronnie Campbell and Roy Caines having a discussion at Rene's fish house, March 1981. *Courtesy of the author.*

beach inside North Inlet and play around in the sand for a while, happy-go-lucky and laughing a lot! They'll be along soon, so don't worry about them."

Well, the afternoon dragged by slowly and we never showed up. Our mother called Rene around five to see where we were. No one knew. Rene told her he would have us checked on if we didn't show up soon. Well, we never showed up. Rene had closed the fish house and went home. We, in the meantime, were still out there in the ocean trying to get the motor started. We killed the battery trying to get it started and then tried to pull start it, after cleaning the plugs and everything else we could think of, to no avail. We knew we were going to be all right. The ocean was calm and the weather was clear. As darkness fell, the air was starting to get a little cold, or as Roy likes to say it, "airish." We took the felt material, the stuff that is like a heavy blanket that we cover our nets with, and wrapped it around our bodies to keep us warm. We figured we would be there all night and when Bobby came in the morning we would get a tow back to town. We never even considered that others might be worried about us not showing up. The thought never even entered our minds.

Others did worry about us, far more than we realized. Rene thought to himself, "Well, I had better go check on the boys and see if they have made it back yet." He drove back down to the fish house a couple of times to see if we had come in. We hadn't. Rene gave Ronnie Campbell a call and they met back at the fish house. They also called Bobby, to find out where we were last seen. Bobby came down to

the fish house too. Rene said, "Them boys have me worried a bit, sure hope they are not in trouble." Bobby told him, "They were just fine when we went by them this afternoon, they were busy putting out their nets. The ocean was calm and everything was fine." Anyway, Ronnie and Bobby decided to take a boat ride back out to the mouth of North Inlet to see if they could locate us.

Ronnie told us later, "That was the longest boat ride I ever took. On the way out, I kept thinking to myself, what if we can't see anything when we get to the inlet, it's now pitch dark and the ocean is dark at night." The closer they got to North Inlet, the more worried Ronnie became. He told us later, "You just don't know how relieved I was when we rounded the point at the inlet and I could see out on the ocean and there on the horizon, a small, tiny, white light shining like a beacon in the night." We had turned on our stern running light for an anchor light. When Ronnie saw that little light, as he told us later, "You just don't know how much of a great relief came over me, as I just knew that tiny little light was you guys, the Caines boys, out there on the ocean."

Ronnie started heading out toward us. Bobby told him, "Hey, you had better turn in toward the shore and run down the beach and once they are straight out from us, then turn and head straight out or you'll run the risk of running over their nets." Ronnie was too excited and wanted to know if that was us and kept on running straight out toward that little light. Bobby was right: Ronnie ran right through our first net. This is when we heard them coming and raised up to see if we could see who it was. All we could see was the bow running lights. From where we were, we could tell whoever it was was at our first net. Then the boat started coming again and sure enough, wham, right into our second net. We could hear Bobby yelling back to Ronnie, "I told you their nets were out here, but no, you wouldn't listen to me, gotta go straight out and tear up their nets." Of course, Ronnie was yelling back at Bobby, but what he was saying we're not sure. One thing was for sure, we weren't going to have to spend the night out on the ocean. Luck was on our side this time.

As they came alongside, Bobby said, "Isn't this right where we saw you this afternoon?" We told him it was and that we had waved a life jacket high into the air, but he must not have seen it. We told them the motor wouldn't start and now the battery was dead, so we hooked up a towing line and off we went, headed back to town. It was about ten o'clock when we got back to the fish house. Once we got back, Rene was standing right there on the dock, waiting to make sure we were all right. Our mother was worried too, as she told us once we got home that she had said a little prayer for us and knew we were going to be just fine.

The next morning we went to the boat shed, a business where we bought our motors and also had them repaired. Sure enough, it was the ignition. We also found out that all we needed to do was cut one little black wire that was running from the motor up to the ignition and the motor would have started, but we wouldn't have been able to turn it off. Who cares? We wanted it running, not stopped. After we

learned this, it has never happened since, but it is still a good thing to know. There's also another good thing to know and that is this: we have friends that care enough to take action when the time arrives. Thank God for good friends.

DRIFTING IN THE OCEAN

As time went by, anchor net fishing in the ocean for shad was outlawed. This meant we were no longer allowed to fish for shad in the ocean with anchor nets, but we were still allowed to drift for shad. No one had ever tried this before. No one thought it could be done, or at least thought it wasn't worth the effort. Roy and I didn't want to go back to river fishing, as we had some of our best seasons while anchor netting in the ocean. We knew that there was not much money working the river. To give you an example, there were times that we caught so many fish while anchor net fishing in the ocean that the boat couldn't carry them all. Bobby, with his much larger boat, would come by and take some of our fish, about three hundred or so, and put them in the bow of his boat. This way, we could finish fishing the nets and carry all the catch back to the dock in one trip. We always appreciated Bobby's kindness. Once anchor net fishing was outlawed, we decided to give drifting in the ocean a try. After all, it couldn't hurt to try. There was no boat traffic like in the river, with yachts, tugboats and other small boats coming by that made you pull the net around or take up part of it so they could pass. The ocean seemed like a better place for us. Unknown to us, Bobby was watching us every day as we came in, sometimes with no catch at all and other times with just a few fish, but nothing to brag about.

We were only putting out about a three-hundred-yard net, about what we fished in the river. After a while, we noticed that there was not much tide out there, so we decided to put out more net. We tried six hundred yards and this helped. But the shad were not running yet. No one was catching any. Then one day, about two weeks into the season, the shad showed up.

We had put our six hundred yards out and were coming back down the line and clearing up any tangled corks so the net would fish clear. We did this every time we put the nets out. This time, it wasn't so much that the corks were tangled as that they were under water. This didn't make much sense to us. We usually put out and may have two or three corks that would need to be cleared up, but this time too many corks were down. As we headed inshore, riding down the net line, we could see there were many corks under water. As we went to each cork that looked tangled, it would be a shad or two or maybe three! By the end of the day, we had over five hundred fish in the boat. A shad can weigh anywhere from three to six pounds, so we had quite a load in our little boat. Plus, unlike anchor net fishing, we had to take up the nets before we could go in, and this added even more weight to the boat. It took a little longer to get in, but it was worth it!

Roy off of North Island, shad fishing. *Courtesy of the author.*

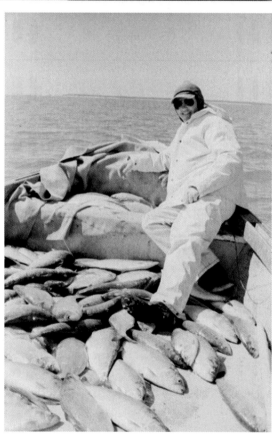

Me with a fair day's catch of shad off Debordieu Beach.
Photo by Roy Caines.

Me off North Island, shad fishing. *Photo by Roy Caines.*

The next day we were out there early. The fishing was even better than the day before. Bobby told us later, "I knew you boys were going to figure it out, so I just watched and waited. And sure enough, once I saw you boys coming in everyday with a load of fish, it was time for me to join you." And that's just what he did. We were glad to have him out there, because you never know when you're going to need help with breakdowns and such. Before he got there, we were all alone. This kind of worried us, but once Bobby came out, we felt a little bit more at ease.

One Year of No Fish, Except for Us

It always seemed that when shad season opened on the first of February, there were hardly any fish. On occasions the season would open with shad already coming in, but in this one particular season, there were no shad at all. Ronnie put out the stake row nets that he fished for Rene and every day he would have nothing in the way of a catch. We were drifting in the ocean that year and we weren't doing anything either. After a couple of weeks of this, we kept trying and only got a fish or two a day. Some days, we got nothing. Bobby stopped coming altogether. Ronnie got disgusted with the stake rows and took the nets up. He was going to wait until the shad started coming in before putting the nets out again.

Roy and I didn't know what to do, as this is how we paid our bills. We had fished for about two weeks off Debordieu Beach and it looked like things were getting pretty bad. So on the third week, Roy came to me and said, "What would you say if we go and do some exploring. I'd like to try our luck down at Santee, just off South Island." I figured, sure, why not, since we weren't doing anything at Debordieu.

Monday morning, we took off for Santee. Arriving there, we went out the mouth of the inlet, down at the south end of South Island. Once we got out of the bar we headed north, and just off South Island we put out just one string of about two

hundred yards of net to test the area out. After about an hour, we checked the net and had nothing. We look at each other and said something like, "Well, this didn't work. What now?" Roy said, "Well, I don't want to try just one spot, since we came so far." So we decided to try the south side of the inlet. Wouldn't hurt.

We took up the net and headed south. Once on the south side, we put the same net out and waited just a little while, about thirty minutes. We checked the net and had nothing. I was ready to head in and said, "Well, there's just not any shad coming in. Let's head for Georgetown, no sense in wasting any more time out here."

Roy, on the other hand, wanted to try one more thing. He wanted to put out closer to the mouth of the North Santee inlet and drift across the mouth. We strung out the two hundred yards once again. This time, we put it out just on the south side of the inlet with the intention of letting it drift north past the mouth of the inlet. While the net was drifting, we went ahead of it and dropped anchor to have a bite of lunch before we would take up the net and head for home. The net came across the mouth and we decided to take it up, as there was no sense in staying out here. As we approached the net, we both noticed a lot of the corks were down. We knew we had cleared them up after putting the net out, so we didn't know what was going on.

We decided to run down the net and check it out and see what was in it. Each cork that was down had a shad. We brought in about ten fish. What's this? Fish? Shad? So we decided to let the net fish a little longer. We went and checked it again after about thirty minutes. This time there were no fish. Well, that was strange, we thought. Then, it hit Roy. "I know what happened," he explained. "We need to drift across the mouth, that's where the fish are, the few that are coming into the river. Let's try that again." I thought that was a bunch of baloney. The fish wouldn't be doing that, since they come in from all directions. Oh well, to humor Roy, I said, "Okay, let's try it again." So we did.

Again, we put out the net on the south side, only this time we added another string to the first net and had out about 350 yards of net and we stayed with the net. As it drifted past the mouth of the inlet, we could see the fish hitting the net. We didn't pick out any of the fish, as it always seems to us that when you leave the fish there, their struggling attracts even more fish to that area of the net. We noticed this while drifting in the river in days past. Once the net had drifted past the mouth, the fish would stop hitting the net. So instead of fishing the net out, we simply started taking it up and picking out the fish as they came in with the net. This time, we picked out about twenty fish. "Well heck, this is working pretty good," Roy stated. So I said, "Sure and we may even make a paycheck today." So once again we put out the net on the south side and did it again. We would put out, drift across the mouth, take up, run back to the south side and do the whole thing all over again. Heck, it was even fun.

When we came in that day, no one was at the fish house. It was closed. It was around six o'clock and everyone had gone home. We had a key to the place, so we

The Glory Days: Our Fishing Adventures

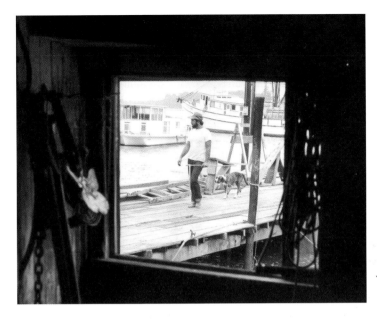

Ronnie coming down the dock. This picture was taken through the office window at the fish house, July 1981. *Courtesy of the author.*

simply unloaded the fish, put them in the walk-in cooler and headed home. Of course, Rene called a little later after we got home, just to check on us, since we hadn't come in before he left for home. We told him we had a few, about a hundred fish or so. Rene said, "Well, I'll pack them up tomorrow for you, just go out again in the morning, as I need the fish." He always told us stuff like that, always needing fish, shrimp or whatever was in season.

Of course, the next day we were able to fish for a full day doing what we had learned the day before. We put out on the south side, drifted across the mouth and took up on the north side. When the tide would turn we had to put out on the north side and drift to the south. We wouldn't catch as well, but we still caught a few, enough to make it worth staying and fishing.

We would come in each day with about 100 to 150 fish. Everyone just knew we were catching them off Debordieu Beach, but we wouldn't tell anyone where we were fishing and how we were doing it. For about three weeks or so, we did this, making a paycheck each week. Bobby went out and tried Debordieu and found nothing, not even us. He said, "I don't know where you are fishing, but I know you found out something that is working for you." And yes, we had.

One day while we were out there, another one of our fishing buddies, Bubba, came out, but went to the north and just off South Island beach and put out a net or two. He caught nothing. We could see him taking up and then running around, looking for us, we thought. Sure enough, later when we came in with our usual catch, we saw Bubba at the fish house. He said, "I went to Santee and didn't see you anywhere." We didn't have the heart to tell him we had seen him, as we didn't really want him to know where we were fishing. If word got out, we would be surrounded

Roy Caines and Buddy Taylor in the fish house, September 1984. *Courtesy of the author.*

by other fishermen. It's a dog-eat-dog world out there. So we just kept our mouths shut and kept on fishing.

We were the only ones making any money during that three-week period fishing for shad. As usual, the shad showed up in March and we were back at Debordieu with Bobby and things were back to normal. Later on, we did tell the other fishermen where we had gotten the fish. After all, it's hard to keep a good story like that all to yourself.

We always thought that it was cool what we had done, discovering new ways to fish. Putting out and drifting across the mouth of the channel, catching a few fish each day while no one else was doing a thing. It was a fun adventure we had there that year, off the mouth of North Santee River.

We always sold our shad to Rene, but there did come a time when Rene decided to quit the business, as it was just getting too hard on him and his age was catching up. So we started selling our fish and doing business with Leonard and Sons. This was another fish market and packinghouse that was run by Buck and his wife, Helen. We sold to them for several years. We were now a part of this fish house.

I remember one season, we had just unloaded a large catch of shad and were about to leave the market when I noticed that Buck's helper was placing nametags on the boxes of our fish that they had just packed up that read "Caines Brothers." Well, upon seeing this, I brought it to Roy's attention. We looked at it and thought, what's this? We had to ask Buck. Buck told us that the packinghouses had been receiving some bloody and terrible-looking fish, while others were clean, had all their scales still intact and looked like they had just been caught. They wanted to know who had been bringing in the clean-looking fish. Buck told us that he told the guy on the phone that it was the Caines brothers' fish and they always came in clean-looking like that.

Our dad taught us to handle the fish like they were gold. When people come into a market to buy fresh fish, they want them to look like they have just been

The Glory Days: Our Fishing Adventures

A fair day's catch of shad off Debordieu Beach. Note how clean the fish look; it was our way. *Photo by Roy Caines.*

caught. We had to learn how to pick the fish out of the net without causing the fish any harm. We cover the fish with felt to protect them from the sun and toss water onto the felt to keep them wet all day. This helps keep the shad fresh and in good shape.

As it turned out, the packinghouses wanted our boxes of fish labeled so they didn't have to look through the boxes of shad to locate the good fish. Buck had all our fish labeled on the side of the boxes. We thought this was neat.

Unknown to us, the places the fish were shipped paid more money for fish of this quality. Each Saturday when we went in to settle up, we made a little more on the pound than the other fishermen. It seems we were the only ones bringing in fish of this quality. Handling our fish like this did have its merits, and it paid off, too. We received more money for showing that we cared about our product.

Sometime later, we were talking to one of our fishing buddies and telling him how our fish got the nametags on them because of the clean-looking fish. Our buddy stated that we all get the same price, because the fish are sold by the weight. Regardless of how they look we all get paid the same. We didn't have the heart to mention that we were receiving more money for our fish than everyone else, so we simply kept our mouths shut.

Buck told the other fishermen to try to handle their fish like the Caines brothers, but it didn't help, their fish kept on coming in bloody. Buck told us not to mention that we were receiving more money for ours, because the others probably wouldn't

Roy Caines on the Oak Hill Drift in the Waccamaw River, catching the low water slack, circa 1980. *Courtesy of the author.*

understand. So we never did. "No one seems to care anymore, no one does. I'm just glad that some still do," Buck said. "You boys are a rare breed and it's always been a pleasure working with you."

We always handled our catches like this and it didn't matter what we were fishing for. Whether it was shad, shrimp, sturgeon or whatever, you had to handle your catch just like you were the one who was going to take it home and prepare it for your own dinner table. We felt that if you had a product you would buy for yourself, then it only made sense to have something to sell to others in good quality. They, too, would be glad to purchase our fish to take home for their dinner table.

Our father made sure we understood this. He told us, "You always have to have quality fish if you wish to make it in this business." I would have to say that it paid off to listen to what our father was trying to teach us and we are grateful for that lesson.

A Whale of a Tale

One season, while we were fishing off Debordieu Beach, we put out our net, checked it out for any tangles and headed back to the beach. We anchored just outside of the breakwater to allow the net fishing time before we would check it out. This was a normal thing that we did each day.

On this particular day the weather was calm and sunny. We anchored our boat just ahead of the net to wait on it to catch up to us. The tide was moving slowly and the net seemed to be almost still. After eating breakfast, we both settled down and stretched out on the boat seats to rest for a while before checking on the net.

Just to the south of us was a fishing buddy, Anthony Hyman. He had out about a four-hundred-yard net and was fishing alone. With a short net like this there is no problem fishing it by yourself. The only problem with this type of fishing is

The Glory Days: Our Fishing Adventures

Roy Caines in my boat drifting in the Waccamaw River on the Oak Hill Drift. Note the sturgeon behind his feet; it was legal to catch them at that time. *Courtesy of the author*.

the lonely part. While we were stretched out in our boat, he could see us from his position and decided to ride over to us to see what was going on with the shad and for some company.

As he approached us, we heard his motor and rose up to see who was coming. Since it was Anthony, we just laid there waiting for him to come alongside. However, he didn't come alongside but yelled out to us. We couldn't hear him very well, so we both got up to see what he wanted. He yelled out, "Did you know that there is a whale headed for your net!"

Of course, we thought he was just funning with us and didn't pay this any attention. We yelled for him to come on alongside. That's when he pointed and said, "No, there really is a whale, look!" As I turned to look in the direction he was pointing, I saw the back of a large humpback whale as it broke the surface of the water. It seems that this whale was simply swimming down the net and headed to the beach, we assumed, to go around the end of the net. Anthony's motor must have spooked the whale, because he turned and headed toward our net. Roy told me to quickly pull in the anchor as he was firing up the motor. Before we could get underway, the whale hit the net and we saw the corks disappear, about twenty of them all at one time. The whale acted like there was nothing there and went right on through the net. The whale took out about twenty or thirty yards of net, just ripped right through it.

The whale was heading south and Anthony's net was next in line. We quickly ran around the end of our net and headed out toward the whale, only it looked like the whale was turning and heading back toward our net. "Oh no!" I yelled. I told Roy to drive the boat in between the whale and our net and as he did, I took our oar and started hitting it on the surface of the water. I hoped this would turn the whale away from the net. The noise that the oar made as it hit the water must have spooked the whale, because sure enough the whale turned and headed offshore. We rode along with the whale, staying in between the whale and the net until we were

Bobby Ackerman with Ronald Micheau (Rerun) at North Inlet during shad season, March 1983. *Courtesy of the author.*

past the end of our one-thousand-yard net. The whale kept on heading offshore, so we knew Anthony's net would be safe, too.

This whale looked to be about twenty-five feet long and had a clean-looking back, so we figured it was relatively young. This was the first time we had ever seen a whale this close inshore. Roy had spotted whales while he fished offshore for swordfish or sharks, but this was a first for us both. Anthony was still there with us and watched as we guided the whale offshore and away from our nets. He, too, had never seen a whale this close to the beach.

We went back inshore, picked up the first net and found that it was torn beyond repair. We simply cut out the part that was torn and tied the two remaining good parts together. This shortened up the inshore net considerably. We had our nets put together in shots of 150 and 200 yards. This way, when we had bad weather, we could put out what we wanted and not overload ourselves. We could even put out two strings of net along the beach when we desired. After the whale incident, we had a really short net for our inshore use.

After the day was over and we were back at the dock, we told Rene of our incident with the whale, but he refused to believe us. He told us we had simply torn our net on a hang and didn't want to take responsibility for our mistake. We're not sure if he ever really believed us or not.

A CLOSE CALL!

One winter, while off Debordieu Beach, we had just taken up all but about twenty-five yards or so of our net and we were just outside of the breakwater right up on

The Glory Days: Our Fishing Adventures

Me with a few shad off Debordieu Beach in the bow of Roy's boat, circa 1987. *Photo by Roy Caines.*

the beach. At Debordieu, the water is very deep right up to the beach. There's not much wave action until you are just a few yards off, and then the waves start to break. This is what makes fishing for shad at Debordieu unique, as opposed to other areas. You can fish right along the shore where the shad are running and your nets barely touch bottom, down twenty-two feet.

We had just about all of our net up as I was pulling in the net and Roy was in the stern running the motor. He would back down the side of the net as I would pull it in and pick out the shad. On calm days, Roy would pull in the bottom line as I pulled in the cork line and this made it easier for us to fish out the net. However, on rough days, he would operate the motor and I would pull in both lines of the net. On this particular day, the weather was rather rough. We had only a few more yards to pull before we were headed in for the day. We were very close to the beach and it was no big deal to us, as we have been this close on many occasions and never had any problems.

This day was to be different. I believe we were a little too close to the beach and wanted to just go ahead and pick up the last little bit of the net before moving offshore to prepare for the trip back to town. We had to cover the nets with our felt to keep the wind from blowing them out of the boat as we ran in. Plus, we had to cover the fish, too, to keep them out of the elements so they would remain fresh and clean.

As we backed down the top line of the net, the bow of the boat was pointed out to sea and the stern was toward the beach. This way, the waves that were coming in as a result of the rough ocean were split by the bow and the boat would simply ride over these waves. Being close to the beach, these waves were getting a little bigger,

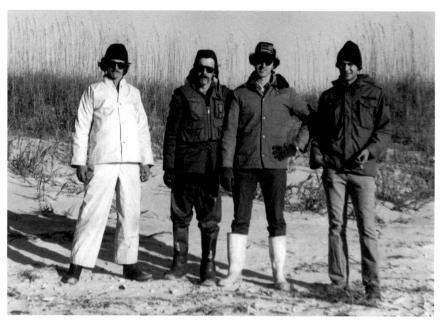

Frankie and Clarence Cherry, Roy Caines and Petey Poit at North Inlet, April 1981. *Courtesy of the author.*

but still posed no threat. As we were busy pulling in the last little bit of this net, a rather large wave was approaching. Roy saw it and yelled out to me to hold on. I looked around and sure enough, this wave was large indeed. And it was headed straight for us.

The wave was on top of us before we knew it. The bow of the boat rode high on top of the wave as it reached us and started to break. This was serious business. With the wave breaking, the boat was standing almost straight up. We started surfing down the face of the wave, only backward. As the boat reached the bottom of the wave, the stern kept on going down into the water. It was almost halfway underwater and was breaking right at the worst moment. All I could see was Roy's hat and it was still on his head. He was underwater and had his hand on the control handle with the motor still running, as the cover formed an air pocket over the motor, which kept the water out. Roy pushed the throttle down and the boat surged forward and shot out of the water like a rocket! All of this happened very quickly, within seconds. The boat came out of the wave and the water was rushing out of the stern as the boat powered ahead. I just knew we were going swimming that day.

Roy yelled at me to quickly tie the net into the rail of the boat. All that was needed was to put the two lines into the rail of the boat and wrap them together. I did this and Roy powered ahead and turned the boat around and we pulled the net farther offshore and out of the breakwater. Then we started pumping the water out

The Glory Days: Our Fishing Adventures

Roy Caines shad fishing off Debordieu Beach, February 1988. *Courtesy of the author.*

of the boat. We had an electric pump and it was throwing the water as hard as it could, but just the same, Roy also started throwing water with a bucket. I continued to pull in the remainder of the net. Once I got the rest of the net in, Roy had the boat pumped out and we got farther away from the shore. We did not lose a single thing when the boat went deep into the surf. That was amazing to us and even more amazing was the fact that the motor kept running and Roy knew to give it the gas to try to get out of that situation.

Remember, it was the dead of winter and Roy was soaking wet from head to toe. The water temperature was around forty degrees and the air temperature was just above freezing. I told Roy to wrap himself in the extra felt we had and I would drive the boat. This way, he wouldn't freeze as we headed in. It's about a forty-five-minute run to get back to the dock. We had to run to North Inlet, cut through Jones Creek to get to Muddy Bay, round Fraser's Point and then cross Winyah Bay to Georgetown.

When we got in, Rene had a heater running in the fish house and Roy almost hugged it. While Roy hugged the heater, I unloaded the fish we caught that day. We stayed there at the fish house until Roy was dry and warm. This was just another close call of many we have experienced in our fishing adventures over the years.

Chapter 6

Our Shrimping Days

We shrimped just like we shad fished, always together, but each in our own boat. There were times we shrimped in the same boat due to breakdowns and such, but for the most part we each had our own separate boat. We started out using outboard motor boats. However, shrimping with an outboard is pretty hard. We would run out with one type of propeller on the motor and once we got to the shrimping grounds we would cock up the motor and change the propeller to what is called a towing wheel. With this type of wheel, you could tow the net and it wouldn't be too hard on the motor. With a towing wheel we would save gas, too.

Roy and I always had a little contest each day and that was to see who could catch the most shrimp. It seems like Roy almost always won the contest. There would be times when I outdid him, but it rarely happened.

One thing we learned about shrimping is to try to always have a new net. Old nets, once pulled and stretched out of shape, can't stand up to a newer net. One season I started out with my older net from the year before and Roy had a new one for the upcoming season. My old net had done quite well the year before, so I didn't see any need for the added expense of a new net.

Upon starting the season, it seemed that Roy always beat me. We couldn't figure it out. We would shrimp right beside each other working the same area. Normally when we did this, one or the other could win our little contest. But this time, I could never beat him. One day I caught a hang, which is something on the ocean floor that the net will tangle up on and stop the boat. Sometimes if you were lucky you could get the net off the hang and not tear it up. Well, this particular time, I tore the net up pretty good, well beyond repair. That afternoon when we got back from fishing we went to see Billy, the local net maker, to order a new net. Good news: he had a net ready to go, so we were back in business without losing a day.

The very first day out, Roy and I had pretty much the same catch. This was unbelievable. Maybe we had a pound or two difference in our catch. This went on for several weeks. Then I caught another hang, only this time I didn't tear the

Our Shrimping Days

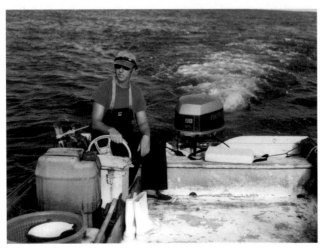

Top: Me shrimping at the south end of Debordieu, August 1987. *Middle:* Me pulling in my shrimp net at the south end of Debordieu, August 1987. *Left:* Me dragging behind the south jetties, circa 1989. *Photos by Roy Caines.*

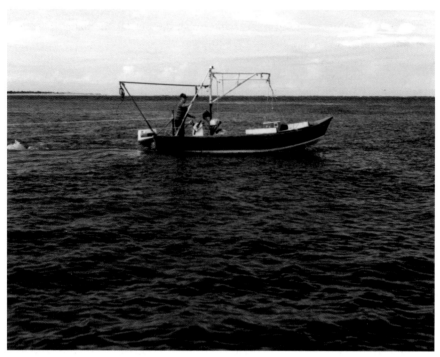

Bobby Ackerman shrimping in the corner at the south jetties. *Courtesy of the author.*

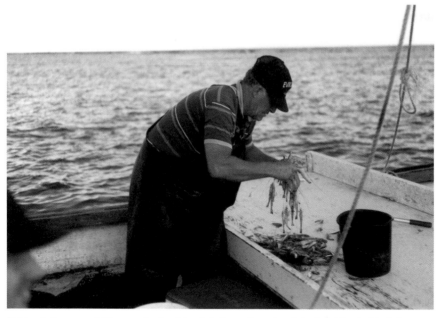

Bobby Ackerman picking up the last bit of shrimp after a hard day's fishing behind the south jetties. *Courtesy of the author.*

net up. It only stretched it out a bit trying to get the net off the hang. From that moment on I fell off from tying up with Roy and his catch. We figured it out: new nets are the way to go.

THE LITTLE SHRIMPER

Roy always wanted a larger boat to get out of outboard fishing. After a few years of shrimping from the outboards, we had saved a few dollars, enough to purchase a new and larger boat. New for us, but an older boat. We didn't want too large a boat, just large enough so we could both work on it together. We had heard that we could find what we were looking for up in North Carolina in an area called Harkers Island.

In the fall of 1984, we took a trip to Harkers Island to have a look around. Sure enough, we found quite a few little boats that were just what we wanted. The only problem was that they were out of our price range. We spent most of the day looking and not really finding anything that we could afford. We figured the day was lost and decided to head home. By chance we stopped to get gas before heading back to Georgetown. We asked the guy at the gas station if he knew of any small boats for sale. Luckily, he had a friend who was trying to sell a small fishing boat he used for getting clams. He gave his friend a call to see if he was home. Sure enough, he was and Roy talked to him and got directions to his home. This man kept the boat right behind his house, as he lived on the bay.

When we arrived, we went out behind his home and could see the boat at anchor out on the bay. This man, Mitchell Smith, had a small skiff that he used to motor out to the boat. We went to look the boat over and liked what we saw. It was a flat-bottomed bay boat, but it was just what we were looking for in the way of a small shrimp boat. There was only one little drawback: it had no cabin on it. There had been one, but Mitchell had taken it off due to rot and was planning to rebuild it, but had just not gotten around to it. It was one of those small cabins that is right up in front of the boat, in the very bow. This type of cabin is popular in the area, but not the type we like or wanted.

We gave Mitchell a deposit to hold the boat until we could come back the next week with the hopes of purchasing it. We needed to have someone bring us back so we could both be on the boat and run it down the waterway to Georgetown. We didn't want to have to leave our truck up there, and we both wanted to be on the boat together to make the trip, as this was to be our first adventure to do something like this.

OUR TRIP DOWN THE WATERWAY

We did return the following week. This time we were more prepared to make the purchase and to bring the boat back to Georgetown. We even brought a friend of

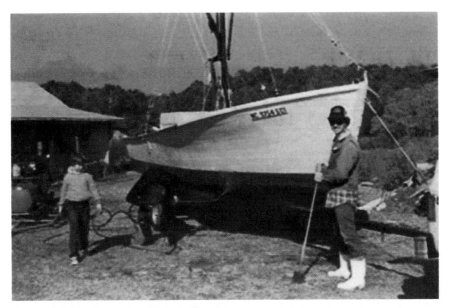

The *Little Shrimper* having her bottom cleaned before we headed south for Georgetown, November 1984. *Courtesy of the author.*

ours, Frankie, who is a very skilled motor mechanic. We wanted to be safe, as we didn't know all that much about engines and we weren't sure whether the motor would make the trip. We wanted a mechanic who knew his way around a motor and Frankie was just the man for it. If a motor could be fixed while underway, he was just the man to have along. We were very grateful to have him.

We bought a couple of new navigational charts to help us navigate the trip back to Georgetown. We didn't want to get lost. Well as luck would have it, there was one chart that wasn't available, but it only covered a small area around Wilmington, North Carolina. We figured since it was the Intracoastal Waterway, we would need only to follow the markers. How hard could that be?

So we were off. We had gotten another friend, Anthony Hyman, to take us up there. He was going up there anyway to visit some relatives of his, so it wasn't that much out of his way. He was also taking his wife and their children. He had a truck with a camper on the back. They rode up front in the cab while Roy, Frankie and I rode in the camper.

Once we got to Mitchell's house, we all had a look at the boat. Mitchell told us he had a trailer he could use to pull the boat out so we could inspect the bottom. We could also clean off any barnacles that were on the bottom so we wouldn't have the drag that they would cause on our trip down the waterway. We took the boat to a nearby boat landing and hauled it out. The bottom was in great shape, but we did knock off a few barnacles that were on the propeller and the bottom. We launched the boat back overboard and we were satisfied with the way the bottom looked. This

Our Shrimping Days

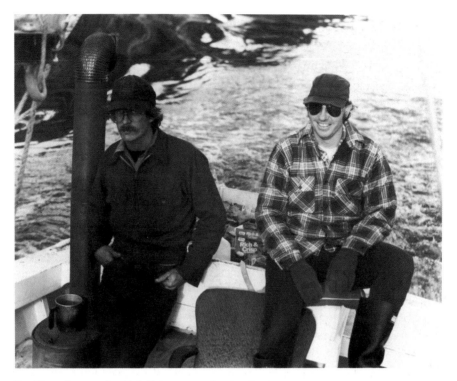

Frankie and me on the *Little Shrimper* as we headed for Georgetown, November 1984. *Photo by Roy Caines.*

was the boat for us, so we made the sale and transfer of ownership. We had what we wanted: a larger inboard shrimp boat.

We left the landing in the mid-afternoon and proceeded to a fuel dock to cap off the gas tank before heading out. Our intent was to travel the Intracoastal Waterway back to Georgetown, stopping only for fuel when we needed it. We brought along a trash-burning heater so we wouldn't get too cold at night and we could also cook on it. We brought all kinds of food, a frying pan and a coffeepot. We didn't drink coffee; hot cocoa was our preferred drink.

After we had been underway for a couple of hours, Frankie started cooking us up some supper. He brought along some steaks and potatoes. I'll tell you, cooking out on the water like that makes food that much better. I am not sure if Frankie did a great job of cooking those steaks or whether it was just the fact of where we were, but that was some of the best food we ever ate. To be honest, Frankie is a good cook.

We traveled all afternoon and right into the night, checking the charts against the markers as we passed them to make sure the marker had the correct number on it. Sure enough, we were right on course. Mitchell had a single running light mounted on the bow deck of the boat. This light didn't last very long and it burned out no less than an hour after we had turned it on.

91

Roy removed it from the deck, placed a flashlight under it and set it up so it was shining forward. This way, we did have some type of running light for our bow. There was also a light mounted on top of the mast that lit up the entire boat.

With the light on, it lit up the white bow deck and this caused a glare that would blind us, so we turned it off to be able to see. We had a spotlight we had brought along so we would have some light on board. The mast light covered this just fine. When we saw a boat coming, we would turn on the mast light so that we would have all the required lights and could be seen by approaching boats. After we passed the craft, we would turn the light off again. This way, we could see where we were going.

Like I stated, the boat had no cabin, so we were open to the elements. Luckily, it was fair weather for the entire trip, only quite chilly at night. We kept the fire burning in the little heater we had until the wood ran out. However, that posed no problem, as we were in the Intracoastal Waterway. We would simply run the bow right up onto the bank where there were trees and break off branches. We had a hatchet and used it to cut the larger limbs. With the fire already burning, it was no problem getting the wood to burn, so we were able to keep warm all night. We had the heater in the center of the boat right by the steering wheel. Whoever was driving the boat could keep warm. We all took turns steering the boat, taking a watch if you will. We stayed up all night talking and telling tales and such.

We pulled into Carolina Beach about four o'clock in the morning. It was pitch dark and the one chart that we needed we didn't have. The waterway had two markers and we had no idea as to which way to go, so we went left, which took us into Carolina Beach. There were docks and yachts on both sides of us, so we had to go slow trying not to make a wake. There were lights everywhere and we could see very well. We all assumed that this was the correct way to go, but it wasn't. After about a half-mile or so, we came to the end of the docks and the end of the water. There was nowhere to go but back! We figured this must be a small harbor and not part of the waterway, so we turned around and headed back. This is where we figured the chart would have helped us and I guess it would have. Except this wasn't the only place we were going to need that chart.

As we came out of the little harbor, we knew to turn left to continue our journey and head south. However, once we made the turn, we went only a little ways and came to yet another turn that had two different directions to go. Which way, we didn't know. We had the spotlight and would shine it one way and then the other. The marker to the left looked like it headed out to the ocean, which it did, but unknown to us, it was also the way the Intracoastal Waterway traveled. The turn to the right looked like the way to go, but we weren't sure, so we decided to take a chance and go right anyway. If it was wrong, it wouldn't take too long to find out.

Our Shrimping Days

Roy on the bow of the *Little Shrimper* as we headed for Georgetown, November 1984. *Courtesy of the author.*

As we traveled we came to more markers and they seemed right, so we figured we had made the correct turn and kept going. After a couple of hours, daybreak was coming and we could begin to see. The little channel we were in opened up to a large bay and Roy said, "This can't be right." We could see a dock across the way and decided to head for that hopefully to find out where we were. This took only about twenty minutes or so and as we approached the dock, we could see a boat headed out our way. As it got closer, we could see it was some type of government boat by its markings. The boat came alongside but didn't tie on, and remained just far enough away to be able to talk to us without shouting. It was definitely a government boat as the men on the bow were carrying AR-15s, a military-type assault rifle. They weren't pointing them at us, but told us that we were heading into restricted waters and we had to turn back. Of course, Roy asked them which way we needed to head to get to the Intracoastal Waterway. They pointed the way, which was back the way we came, but more to the right we could see the markers in the distance and off we went. After we got away from that boat, we all started laughing, saying things like, "Wow man, we were all about to get shot! Boats coming out after us, with guns all over them and a blue light flashing! Wait until they hear about this back in Georgetown." We really had a good laugh over that one.

Me steering the *Little Shrimper* as we headed for Georgetown down the Intracoastal Waterway, November 1984. *Photo by Roy Caines.*

As we headed toward those markers, we could see a dredge that was working in the channel. Roy said, "That dredge is working in the ship channel that heads out to sea. The waterway runs with it and then turns back to the right and heads south. So we'll have to pass that dredge and try our best and get around them without getting in their way." Of course, it was no problem getting by; we simply went around them. There were pipes everywhere, little tugboats and such, but the channel was kept open.

After we got back into the waterway, we figured we had lost about four hours because of making the wrong turn. It was no one's fault, as we had to make a guess as to which way to go and, as usual for us when it's a fifty-fifty chance, we made the wrong decision. Oh well, we just kept heading south and soon we came to markers that matched the next chart we had. And that was the end of our trouble with making any more wrong turns, which would have been hard to do as the waterway was now like a large ditch and we only needed to keep in the middle to keep going.

We traveled all day. We each took turns taking a little nap, as the trip was starting to take its toll on us. In the afternoon, Frankie cooked some hamburgers and fried up some French fries and once again we had a great meal!

Our Shrimping Days

We pulled into Georgetown about ten o'clock that night and tied up at Rene's fish house. Since we had a key to the fish house, we opened up the place and gave Clarence, Frankie's brother, a phone call to come and pick us up for a ride home. Well, when Clarence got down there, we all went out to see the boat. Clarence looked it over and thought it was a nice little boat we had found. "It should make a great little shrimp boat for you guys, as it was just what you were looking for," Clarence said. We didn't get home until about midnight. When I went to bed, I slept until after one o'clock the following day. That was the end of our adventure down the Intracoastal Waterway—our one and only time to do something like that!

That same afternoon after I got up, we went down to Rene's with Clarence, who wanted to hear the engine run to see what kind of shape the motor was in. Just our luck, it seems we came back on seven cylinders, as one was not firing. It turns out that the engine needed an overhaul. Clarence got the job and had the motor running sweetly in no time at all. That same engine ran for over ten years, season after season, before it needed to be replaced after simply wearing out.

Roy and I went to work designing a cabin for the boat. We knew about what we wanted. It took about three weeks, but we had our cabin built and the little boat looked pretty good, if I have to say so myself. We were not planning on fishing the boat that same season, as it was about over. We planned to have it ready by the following shrimp season, and we did. I kept on shrimping from our skiff by myself and Roy ran the *Little Shrimper*, which is what we named the boat, so we could have two boats running. Roy would tow the skiff behind the *Little Shrimper* and I would sit in the cabin with him and shoot the breeze as we headed out each morning. Once we got to the ocean, I would jump into the skiff and head off to the fishing grounds to start my day. Roy would also start shrimping and we would put all of our catch together and sell everything as one catch. It didn't matter who caught the most, as long as we each caught, and once again, Roy always seemed to outdo me. He had a stronger pulling rig with the *Little Shrimper*, so it wasn't really a contest when I went up against him like this. But hey, we always got along well together, so it didn't really matter who outdid whom.

We shrimped like this for years. There were times, however, when Roy would spend a season swordfishing or working on the deck of a shark boat. When the shrimping seasons were not good, he always seemed to find work that paid off. I always stayed home, shrimped out of our skiff and took care of our mom. Roy would sometimes be away for months at a time. The boat he was on would sometimes head up north or go down south to do their fishing, so he could be gone for quite a spell.

Even so, I would continue to shrimp here and run our skiff by myself. My favorite place to shrimp was behind the south jetty, which is a great place to drag your net because there are very few, if any, hangs back there. Also, when I would get there early in the mornings, I was usually by myself. No other boat would be in sight and

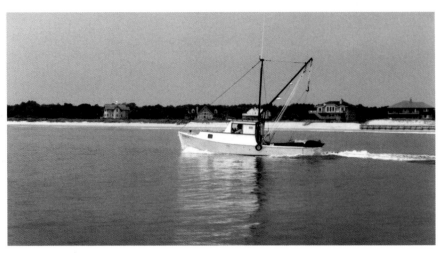

The *Little Shrimper* heading in after a hard day's fishing at the south end of Debordieu, August 1987. *Courtesy of the author.*

I would have the whole place to myself. This made for a great day of shrimping, because no other boat was there taking part of the catch. That is, when the shrimp were there. Most of the time they were. Most of the other shrimpers preferred to shrimp down Santee way, which made it great for me.

Also, running from town, this was the closest run you had to make to be on the fishing grounds. Plus when the tide was up, you could go into the corner where the rocks of the jetties meet the beach and float across the rocks. This way, you didn't have to run out and around the south mound and all the way back to the beach just to get behind the south jetties. Because this saved so much time and fuel, there were times when we would take chances. When the tide was low, but not so low that it couldn't be done, we would attempt a crossing. There is a certain place right in the corner, out about 150 feet from the shore, where a certain rock has a large point on it. This is our marker. Just inshore from this pointed rock, there is a flat little surface that the water runs over and when timed just right your boat will float right across the jetties. You did, however, have to cock up your motor as you went across. If you didn't, you risked the chance of damaging your propeller. We had power tilt, which meant you simply pushed a button and the motor would lift up. Push it the opposite way and the motor would go down.

I would leave the motor running as I brought it up just barely in the water to give me steering power. Just as the motor would reach the rocks, I would bring it up out of the water. The boat would float across the rocks and I would immediately put the motor back down and continue away from the rocks. This would save about thirty minutes, as the south jetties run out about two miles into the ocean. When the sea was rough, you had to run slow, which meant it could really take a while to get out there and back again.

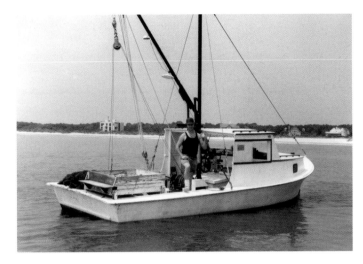

The *Little Shrimper* with her captain, Roy Caines, at the south end of Debordieu after a day of shrimping, August 1987. *Courtesy of the author.*

Once you got behind the south jetties, the rocks themselves blocked the wave action and you could shrimp without any problems from the rough water, which is another reason that it's nice to shrimp behind the south jetties.

JERRY TO THE RESCUE

There was one season when Roy was shrimping the *Little Shrimper* and I was working out of the skiff. We had a friend named Charlie who had just bought his own little boat and was learning to shrimp. We were showing him the ropes and he kind of paled around us. We had been shrimping behind the south jetties and were headed there on this particular morning. When we got there the tide was too low to jump the rocks in the corner, so I stayed with Roy, who was towing the skiff out for me. Charlie was there too, only following us out. As we got behind the south jetties, I cut loose and got ready to shrimp. We all noticed what appeared to be a thundersquall offshore. It looked nasty, but since it was offshore, we saw no problem and went ahead and put out our nets.

Well, Charlie's boat was not as large as ours and he didn't put out right away. He watched us for just a little while and decided that if we were going to shrimp, he might as well, too. He put out and started making his first tow, the same as the rest of us, as there were several other boats there too.

The storm didn't stay offshore. Since we had a southern flow, the storm was headed our way. We figured it would pass and not be any real problem, as we had ridden out many storms like this before without any trouble. As this storm got closer, we could feel the air getting cooler and the wind starting to blow. When the storm reached us, the wind was blowing at a gale force. As the rain reached us, it came down so hard no one could see past the bow of their own boat. With the rain being pushed by the wind, it felt like bees stinging you as it hit. We all had little two-way

Roy in the bateau shrimping in Mother Norton, across from the Georgetown Lighthouse on Winyah Bay, fall of 1983. *Courtesy of the author.*

radios and were in contact with each other. As the storm moved onto shore, we simply kept on dragging.

Soon, I heard Charlie come on the radio and tell both Roy and I that he was taking on water and the little pump could not keep up with it. What should he do? Roy came on and told Charlie to use a bucket and throw water to keep himself afloat. Just moments after that, we heard Charlie come on the radio yelling for help, shouting, "The boat is sinking!"

As he was talking, the radio went dead. I knew he had sunk. With the rain still coming down hard, I couldn't see anything. I knew about where Charlie had been just before the heavy rain. I quickly hauled back and got my net aboard and headed out toward where I thought Charlie was, but still I couldn't see a thing. After running just a little ways, I saw a mast light and headed for it and it was the *Little Shrimper*. I ran toward Roy and yelled out, "Which way is Charlie?" Roy pointed toward the south jetties and said, "I last saw Charlie going toward the rocks and the corner." I took off toward the jetties and as the rocks came into view, I could see Charlie's boat. All you could see was his bow and it was upside down and his poor boat was bouncing up against the rocks. There was Charlie right up on the rocks himself, waving his arms at me. Boy, I'll tell you, I was glad to see that he was all right. I came up alongside him, but couldn't get too close because the wind was still blowing and with the tide rushing in, I didn't want to get washed up on the rocks myself.

I yelled at Charlie, "Stay right where you are, I'll have to jump the rocks." Of course, he couldn't hear me. As I went into the corner, Charlie thought I was leaving him. I jumped the rocks and went back out to where Charlie was and

Our Shrimping Days

The *Miss Esther* shrimping off Debordieu Beach, August 1987. *Courtesy of the author.*

came up alongside him. Being on this side of the rocks, the incoming tide kept me pushed off the rocks and I was able to pick up Charlie without damaging my boat. As we watched, the tide came up and his boat soon washed across the rocks upside down. All of his equipment was floating everywhere and heading up the bay, as everything was washing in with the wind and the tide. We ran around and chased down everything we could see and retrieved what we could find. By now, the rain was letting up and we could began to see again.

After picking up what we could, we headed back to the boat at the rocks. The boat was held there by Charlie's towing lines, as his net was on the outside of the rocks while the boat was on the inside. We went to the boat and as I pulled up on one side of the boat, Charlie got on the other side and with his body weight rolled over the boat and set it upright. We cut the towlines and tied a rope to the bow of his boat and gave tow. We were not trying to tow it in, but to wash out the water. When you do this to a boat, the water washes out of the stern to a point where you can get in and bail out the rest of the water. In the meantime, Roy had taken up and was coming in, as he wanted to help Charlie too.

By the time we got Charlie's boat bailed out, Roy was coming up alongside. We tied Charlie's boat behind the *Little Shrimper* and Roy headed in towing Charlie's boat. Charlie and I headed toward North Island and picked up a couple of coolers and a gas tank that had blown up on the beach. We ran back to Roy and he towed us both back to Georgetown. We got aboard the *Little Shrimper* and talked about the little ordeal all the way back to the dock. Roy told Charlie that we would run back to the jetties later that evening, once the tide was low, to retrieve his net. And that's just what we did.

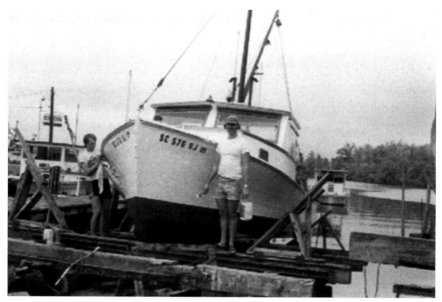

Michael, my nephew and Harrell's youngest son, and me getting the *Little Shrimper* ready for the upcoming shrimp season, June 1987. *Photo by Roy Caines.*

That was the only time I ever rescued someone in peril. I have given many a tow because of breakdowns, but never rescued someone because of a disastrous situation. Just like my dad, Hucksie, I stared danger in the face and did what I had to do to help a friend.

MY ART CAREER NEEDED IMPROVING

Sometime around 1983 or '84, our mom was starting to get along in years and it was apparent that she could use a little help getting around and some attention was needed for her care. Roy and I were still shrimping during the summer and fall months, but I was growing a little tired of this type of work and wanted to pursue my career as an artist.

Roy and I were talking one day and Roy told me that the type of work that we were doing was not the type of thing that he wanted to continue into our twilight years. It would simply be too hard on us as we grew older. It was hard on us at this age. Heck, I was in my forties.

Roy told me, "I will continue to shrimp while you stay home with mom and care for her. This way, you can practice your art and try to improve." He thought I was pretty good already, but I felt I could do better and time would prove I was right.

This particular year Roy tried something new that was going around. It was found out that you could pull two shrimp nets behind a skiff by using a sleigh. You still only needed to pull one set of doors to spread the net, but you had the sleigh

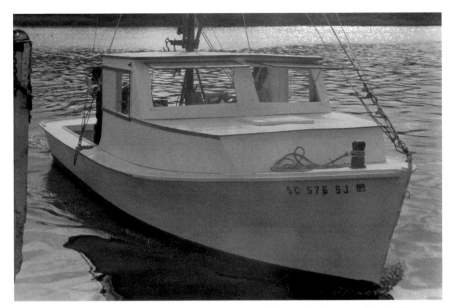

The *Little Shrimper* with Roy at the wheel and Clarence Cherry in the stern, May 1985.
Courtesy of the author.

in between the two nets and a third attached to the sleigh. This proved to work out great. You almost doubled your catch. Only problem was, you could only tow on hard, sandy bottoms. This type of rig wouldn't work very well on the inside, the bays and sounds where the bottoms may have soft mud. The sleigh would bog down and stop the boat. However, for ocean fishing, this posed no problem, as the ocean floor where we shrimped is a hard, sandy bottom.

With Roy shrimping like this, the catch was enough by itself to be able to support us both. I stayed home and started to work on my art and our mother really enjoyed the company. She, of course, kept up with her soap operas and such, but still enjoyed not having to be alone all day.

Roy and I made a pact: if I ever made it as a successful artist I would not forget what he had done for me. I told Roy not to worry, that I would always work with him and we would work together with my art, should I ever make it.

During the next two years, we worked this plan with Roy bringing in the bread and butter while I stayed home to learn to paint. It was around 1985 that I tried to go professional. By tried, I mean I started to sell my work. We approached art galleries, attended art festivals and entered art shows and competitions. We did make a few dollars, but nothing to write home about. We covered my art supplies and such, but it was still not enough to pay the bills.

This went on for a while, but we just couldn't seem to make it click. We even approached the Southeastern Wildlife Exposition, but met with rejections, stating that there was no room left for us in the show because we had not applied early

Roy heading in after a hard day's shrimping behind the south jetties, running by Fraser's Point, just inside Muddy Bay, circa 1989. *Courtesy of the author.*

enough. The following year we did apply early enough but we were still met with rejection. They stated that there was not enough room, as most of the people from last year had taken all the spaces, so we were out again. Well, that was enough for us. I decided to go back to work fishing with Roy, and our mom was once again all alone at home. Now don't get me wrong, she was not so sick that she needed nursing care. It wasn't like that at all. It was just that she was getting on in years, but could still get around on her own. A few years later, she took sick and was placed in the hospital, and a couple of weeks later, in April of 1991, she passed away. This was hard on both Roy and I, but we did manage to get through it.

I always wanted to get back to doing something with art that I could make my living with, but just didn't know how to go about it. In the late '90s, Roy had stopped shrimping and went to work doing construction. This was not something he wanted to do, but hey, it paid the bills. It was around this time that he went to Schofield Hardware one day and a whole new world was opened up to us.

Chapter 7

Our Decoy Carving Days
How It All Began for Us

S hrimping during the mid-'90s proved to be more than we could bear. It wasn't that it was hard work, but the economy of shrimping was down so low that we and most other fishermen found it hard to pay for expenses, let alone make a profit for ourselves. We tied up our boats and were seeking work elsewhere.

For me, I stayed home and returned to painting pictures and trying to improve on my craft. But this seemed like it was going nowhere and I found it hard to make a living from my work, so I soon gave up on that too. As for Roy, he worked on what we call super trawlers. These are the larger shrimp boats, sixty to eighty feet or so. Roy wanted to continue shrimping, so he went to work for Jeff Johnson, someone we had known for a while, aboard the *Miss Esther*. Roy enjoyed working with Jeff, as they got along very well. Roy worked with Jeff for several years. Then, in the final year with him, the engine in the boat blew up. Well, that put them out of work, but this was in December, so the season was pretty much over for that year anyway. Jeff simply tied up the boat with the intent of having the engine rebuilt in the spring. To this date it has never been rebuilt. In fact, the boat is on Goat Island, a small island in the Sampit River right in the middle of town. The boat was pushed up on the shore of Goat Island after sinking at the fish docks of Independent Seafood. It is still there today.

The following year Roy signed on to the *Rock n' Roll*, a shrimp boat owned by Allen Miller, another fishing buddy we always got along with. Roy worked for him for about three years. Here, too, the economy was beginning to take its toll on the super trawlers and making money was simply getting too hard for the shrimpers. In time, Allen sold the *Rock n' Roll* and went into business for himself doing construction work such as repairing fish docks, back porches or whatever handyman type of work he could find. Roy went to work for Allen and worked for him for a couple of years and was still working for him when things started to happen that brought about our current decoy carving days. Here's the deal.

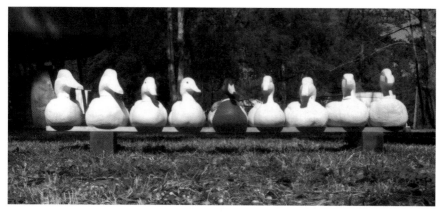

Getting our ducks in a row, January 2006. This is our first set of duck decoys, with the center one completed and the others still in progress. *Courtesy of the author.*

One afternoon while working for Allen, Roy was sent to a local hardware store, Schofield Hardware, to pick up some supplies for the job they were on. As he was checking out, the store manager, Buddy McCutchen, told Roy he had something he wanted to give him and his brother Jerry. As it turned out, he had a printer make up some shirts to sell in the store that had the Caines brothers snakey-neck duck design on them—a small design on the front and a larger one on the back. As Roy was looking at the shirts, he told Buddy, "Guess what? Jerry has a painting he did of that very design." He wanted to know if Buddy would like to see it. Buddy said he would and Roy responded, "Well, I'm working right now, so I'll be back later with Jerry and we can bring the painting in for you to see." Buddy said, "Sounds great. I'll be looking forward to seeing it."

I believe a couple of weeks went by before we ever got to go down there and pick up our tee shirts. We simply kept forgetting. Finally, one day Roy had to go there and pick up some more supplies for Allen. While there Buddy told Roy that he still had the shirts for us, and Roy told him that we would be in the following Saturday to pick them up. Buddy told him, "Make sure that you bring the painting in for me to see." "I sure will," Roy told him.

Well, the following Saturday, we did manage to go down there to pick up our shirts. We didn't bring the actual painting, but rather a print of it that we already had framed and was ready to hang. When we came into the store, Buddy was there behind the counter and had the tee shirts there for us. He presented them to us and we really liked those shirts. The design looked great, and they were done quite well and really looked sharp.

We had the print in a large black carrying case so it wouldn't get damaged while transporting it. Buddy was excited to see it, so we didn't waste any time in bringing it out. His wife, Bobbie, was there also and told us that it was the most beautiful thing she had ever seen.

Our Decoy Carving Days: How It All Began for Us

Buddy McCutchen showing the new Winyah Bay Heritage Festival pluff mud tee shirts at Schofield Hardware Store, October 2006. *Courtesy of the author.*

Buddy wanted to know if we would sell it. Roy told him, "Sure, that's why we make them, to sell." Buddy wanted to know what price we wanted for it at wholesale, so he could put it up for sale in the store. Bobbie spoke up right away, "This is not going up for sale in the store, no way! I'm taking it home with us. It's going to our house where I'm hanging it in our den. No way is it going to be sold. I want this one!" And get it she did.

We told Buddy that we had more and it wouldn't be any problem to bring more down to the store to see how it went. Buddy agreed and we were in business. I think we brought about three down there, just to see how things would progress. Now Buddy wouldn't just take them into the store on consignment to see how they would sell. He wanted to pay us right up front for everything. He knew we were having it hard, as all fishermen were. Buddy simply paid us for everything we brought down there. We had a few other prints of my paintings and we wanted Buddy to see these, too. We never expected him to purchase everything we had, but he did.

To our surprise, Buddy called us up in the middle of the next week and wanted to know if we could bring a couple more of the snakey-neck prints to him on Saturday, as he had sold out of the ones he had and needed more. I told him, "Sure, we'll be glad to." And so we did. This time we took four more prints down to the store. He purchased all of them. We couldn't believe it. I had been trying to sell my work for several years and had pretty much given up. Now they were suddenly starting to sell. This was wonderful!

It looked like we were finally in business. This was in November 2004. Buddy would call us up just about every week to get more prints. He said he just couldn't keep them. It was great. This went on right up until Christmas and then it was over.

One Saturday while we were at the store, Buddy asked me if I was still painting. I told him no, that I had to give it up. There was not much money in it, so I had retired. Buddy asked me, "Do you think you would come out of retirement to paint another picture?" I told him I wasn't sure. I wanted to know what he had in mind. He told me, "I have a photograph of a Caines brothers black duck drake and

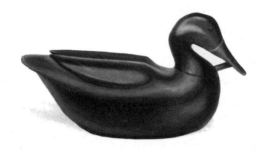

A black duck decoy carving by Hucks Caines. This is the painting done for Buddy in December 2004. *Courtesy of the author.*

wanted to know if you would turn it into a painting for me." I said, "I don't know." Then Buddy said, "Well, would you come out of retirement for $1,000?" Right away I said, "I sure would, in a skinny New York minute."

He had the picture in the office at Schofield Hardware and brought it out for me to take a look at and see if I thought I could work from it. I told him it wouldn't be a problem, as I use photographs for reference all the time. I took the photograph home and started to work on the painting right away. I had it completed the following week, but had to give it time to dry so I could put a coat of picture varnish on it. When this was dry, Roy and I took it down to Buddy at Schofield Hardware. We arrived just before closing time. This way, we could show the painting to him after the store was closed and not be bothered by customers in the store. Upon arriving, Buddy was so excited and could hardly wait to see the painting. We had it in our carrying case and took it into his office. We took it out of the case with the back toward Buddy and his wife Bobbie and then made a presentation of the painting to them by turning it around slowly. They gasped at the sight of it. They were grinning from ear to ear.

Buddy couldn't get his checkbook out fast enough. They were truly delighted with the job I had done for them on that painting. On one of Buddy's first hunting trips he had shot a black duck and now they are his favorite. With this painting being of a black duck, a Caines brother decoy and painted by a Caines descendant—yours truly—it carries a special meaning and merit for Buddy. To this very day, Buddy has stated that he wouldn't take a million dollars for it.

Sometime later, Roy and I were in the store and Buddy asked me if I had ever attempted to carve a decoy. I told him that I hadn't, to which Buddy stated something like, "Do you think you could carve a duck decoy?" I told him, "No, I couldn't do anything like that. I don't even think I could make a toothpick out of a matchstick and with the help of a pencil sharpener." Everyone laughed at this.

After we left the store, I told Roy, "You know, I might be able to carve a decoy, I really don't know what I can do until I try, right?" Roy stated, "Why don't you try one and see how it turns out?" So I decided that I would give it a shot.

Our Decoy Carving Days: How It All Began for Us

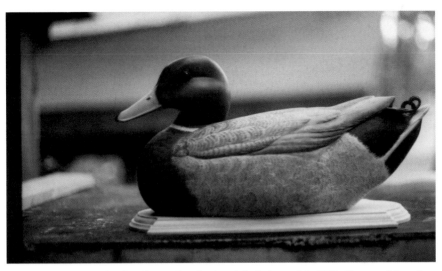

A mallard drake, my first hand-carved and painted duck decoy, July 2005. *Courtesy of the author.*

THE FIRST DECOY

I didn't know the first thing about carving decoys or anything related to decoy making for that matter. So I set out to find what I could about the making of wooden ducks. I purchased a couple of books on the subject, but reading and looking at pictures didn't seem to help someone who had no idea as to what he was doing. I looked over the pictures and read a small part of one of the books I had, but it seemed hopeless.

Then, by chance, I found an ad in a decoy magazine offering a video on the subject of decoy making. It was one of those television shows that air on educational television and they had put together a series of shows to make this tape. I ordered it right away.

Upon the video's arrival, I couldn't wait to view it. At last, I had something that gave me the idea of how to start and how it was done. It just makes more sense to see someone working than what you might read in a book on a subject like this. After I had viewed it, Roy watched it with me and said, "Well, that makes it look like it won't be so hard. You can see how they are doing it."

Sure enough, I had what I needed to make a start at my first decoy. I had decided to make a mallard drake, as this is a popular bird around here. Now I had my materials, but I had no wood. After looking through the same magazine where I had found the tape, I discovered a company that sold carving wood for decoy carvers. So Roy and I decided to order a couple of pieces of wood so I could start on the making of our first decoy.

In January of 2005 the order came in and we had our wood. I asked Roy if he could give me a hand at trimming the block and bringing the wood down to the

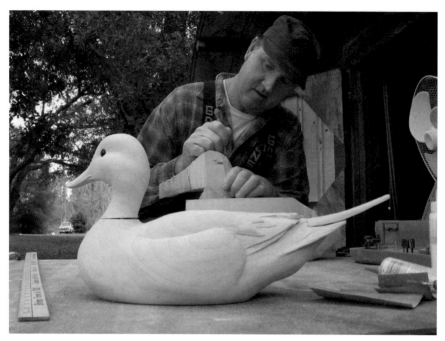

Roy Caines working on a canvasback drake with a pintail drake in front, February 2006. These are the two that won the ribbons in Ocean City, Maryland. *Courtesy of the author.*

shape of the mallard I wanted to do. For the head of the bird, we had also ordered a smaller block of the same type of wood, which was gum tupelo. The head would be carved separate from the body and attached later. This is how it is done, as we had learned from the tape.

I went to work right away trying to make my first ever duck decoy. Roy and I had purchased a large book that had decoy plans laid out in it to help us get the proportions correct. We had no band saw, which is what is usually used to cut out the blocks of wood. We simply used what we had on hand: a skill saw and a reciprocating saw colorfully known as a saw-saw. We made copies of the plans and cut them out so we could lay them on the wood and trace them out. Once this was done, Roy used the two saws and cut out the blocks as best he could.

He handed the cutout block to me and it was now my turn to see what I could do with it. I had purchased a zip drive, a carving tool made by Dremel Tools, which I would use to do my basic shaping. I went to work in February of 2005. I didn't work too much at a time, as I worked outside and at times it was just too cold. We have a table set up in front of our tool shed and this is where we do our carving. I would work on it, off and on, but never really in a hurry. As winter gave way to spring, the weather got warmer and I could work for longer periods of time on the decoy.

I started working on the head and making the bill first. The head was roughed out and we were beginning to see what was taking place. I worked all day on getting

Our Decoy Carving Days: How It All Began for Us

Me at our carving table, making decorative duck decoys: a roughed-out canvasback drake in front and a completed carving of a pintail drake in front of me, February 2006. *Photo by Roy Caines.*

that bill just right, only to have Roy come home from work, look at it and tell me, "That bill is too big. It doesn't look right." I told Roy, "I thought it looked a little too big myself, but I thought it would be all right."

Roy said, "No, it doesn't look right, it's got to look right or people will laugh and we don't want that. After all, it's going to be a Caines decoy and it's got to be right. Don't you agree?"

So I asked Roy. "Well, what can we do, I would hate to destroy what I had already done." Roy simply stated, "Don't worry, Jerry, I'll take care of it." And he did! He got out our grinder, a large sander with a rough disk on it, and put the duck head into our vise and began to grind the bill into shape. All my refined work was totally destroyed, but the bill was more to the proper scale and it started to look correct in relation to the bird's head and body. We now had a start and hopefully would have a decoy that would look correct. I then went to work and added all the details as I had before, only this time the bill looked correct in relation to the head.

It was around this same time that the Georgetown County Museum had commissioned me to create a painting for them of three of the Caines brothers and Chef Charlie, the cook at Hobcaw. I was to create this painting from an old photograph that was owned by the Belle W. Baruch Foundation, with their permission, of course. I put aside the carving for a while in order to complete the

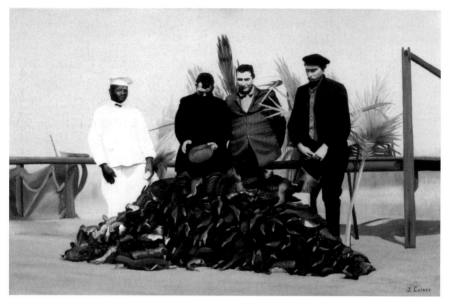

A Fair Day's Hunt, depicting Chef Charlie McCants and Bob, Hucks and Sawney Caines. The painting measures twenty-four by thirty-six inches. *Courtesy of the author*.

painting. I wanted the painting to show refined detail, so I decided to make it rather large, at least large by my standards. It was to be twenty-four inches tall and thirty-six inches wide. The photograph was in black and white, so I had to make up the colors that I thought would work well in the painting. I always keep a record of the number of hours it takes me to complete a painting. This painting was the longest on record that I completed: it took me sixty-two hours to finish it. The painting was completed on March 7, 2005.

Buddy and his wife Bobbie were the first to come by and see the painting. Roy and I took them into my studio, which is really our dining room, for the first viewing of *A Fair Day's Hunt*, the name I had given to the painting. Upon viewing it, they thought it was wonderful. They loved the name, too.

The museum manager, Debbie Summy, proposed that the painting would be unveiled at the museum on June 9, 2005. I was almost through with the decoy carving but had not started the painting process of the decoy. With the unveiling date a couple of weeks away, I thought it might make a nice touch to unveil the decoy carving at the same time of *A Fair Day's Hunt*, as a surprise for the guests.

With the carving completed for the decoy, I thought the painting of it wouldn't take too long and I was in no rush to get started. Not realizing that I had to paint each and every feather, the painting process was going to take a little longer than I had figured. As the unveiling date approached, I realized I was in trouble unless I got to work right away. I started painting the decoy and stayed on it all day for several days in a row, until I had completed it. It took just over a week to paint that

Me, Goley West and Roy Caines, June 2005. In the background is the nursing home aide for Goley, Carrie Flemming. *Photo by Becky Yarbrough.*

one decoy. I had it finished just two days before the unveiling and that, for me, was cutting it close. But I had completed my first attempt at carving a decorative duck decoy.

I took the decoy to the museum the same day I had completed it, to show Debbie and to give her my idea of unveiling it along with the painting. I hadn't been sure I would have it completed before the unveiling of the painting, so I had said nothing to anyone. Of course, Roy said nothing either.

I went alone to the museum, as Roy was out working with Allen. I had the decoy wrapped in white towels and placed in a cardboard box. As I entered the museum, Debbie saw me with the box and I told her I had a surprise for her. At the time, she was talking with someone and needed to complete her business. I understood and took the box and went on into the museum to where the painting was hanging. The painting was covered so no one could see it. I set the box on the floor in front of a counter and waited on Debbie to complete her business. I could see her in the office and she kept looking out at me. She was so anxious to see what I had in that box that she could hardly pay attention to her business.

After the person left, she came out and told me, "I am so curious as to what you have in that box, it's like Christmas morning!" I told her, "Oh, it's nothing, just a little surprise I had for the museum." Then I went about opening the box and I lifted the decoy out, still wrapped in the towels. Debbie said, "I am so excited, I wonder what you've got? I can't wait to see what it is. Come on, hurry up, open it up already!"

As I unwrapped the decoy, Debbie's knees almost buckled, her mouth opened wide and she almost lost her breath! That's when I told her, "Life is not measured by the amount of breaths you take, but rather, by the amount of moments that take your breath away." She was speechless! This is when I told her my idea to unveil the decoy at the same time we unveiled the painting. She loved the idea.

Thursday came and at 5:30 in the afternoon it was time for the unveiling. No one knew of the decoy and we kept it a secret. Buddy was there and was to accompany me in unveiling the painting, him on one side and me on the other. There was such a crowd there that the little place was packed with people. I had never had a moment like this in my life, people coming out to see something that I had done, something that I had created.

Little did they know of the decoy that was waiting in surprise. There was a beautiful little speech made by Lee Gordon Brockington, the senior interpreter for the Belle W. Baruch Foundation at Hobcaw Barony and a local author, just before the unveiling. Then Buddy and I were given the word to unveil the painting, *A Fair Day's Hunt*. As the cover came down, everyone clapped and the clapping lasted for a long time. It was wonderful; I was on cloud nine. Then, after a few moments, Lee Brockington told the crowed, "Just a minute, Jerry has another surprise for you." She instructed Buddy and me to unveil the glass showcase that was on the counter. As we pulled the veil from the glass showcase, the decoy became visible. I said, "This is an original Caines brothers decoy" and the people gasped and the cheers went up to a deafening roar! Talk about being on cloud nine—I don't think I could have been any higher.

I stood there by the painting and decoy to greet people as they came by. I think I knew most of them, but of course there were people I didn't know. I was also glad to have Roy there and our sister, Patricia, and her daughter, Wendy, as well as our older brother, Harrell, who brought along Harrell III, his grandson. Roy stated that he was proud of me and what I had accomplished. This was indeed a great day for me and for the Caines family.

After the viewing, the museum had arranged a reception at the Hobcaw House on the plantation. For those who went there, a guide was waiting at the gate to show the way, as there are so many roads that one could easily get lost. This was the first time that I could recall being inside this house. My sister, Patricia, and I had accompanied our father there sometime back in the '60s, but even then we didn't go inside. So this was a first for us.

It was one of the most beautiful homes I had ever seen, truly fantastic. One would have to see it to really appreciate it. A lot of the people did come to the reception and we talked well into the night. So many of them knew our father and spoke highly of him. This was the perfect ending to a great day. Indeed, a day to remember.

Our Decoy Carving Days: How It All Began for Us

Left to right: Harrell Caines; me; Goley West (seated); Goley's daughter, Becky Yarbrough; Roy Caines; Patricia (Caines) Holmes; Harrell Caines III; and Patricia's daughter, Wendy (Holmes) Shannon. June 2005. *Courtesy of the author.*

Foreground: Harrell Caines III, Harrell Caines Sr. and Goley West. *Background*: Goley's nurses aide, Carrie Flemming; Beverly Nobles; Debbie Summy; and Rebecca Moody. *Photo by Becky Yarbrough, June 2005.*

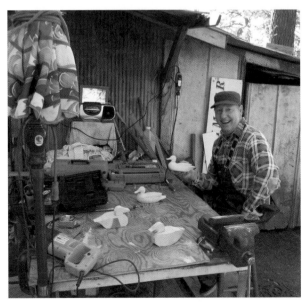

Me at our carving table making miniature duck decoys, March 2006. *Photo by Roy Caines.*

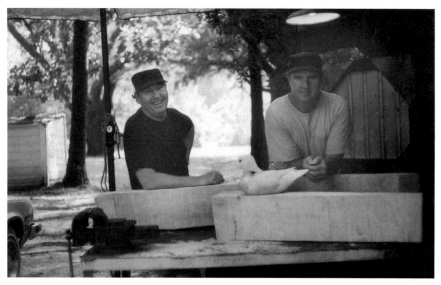

Roy and me at our carving table, August 2005. The tupelo was a gift from Frank M. Beckham of Pawleys Island, South Carolina. Our second decoy, a wood duck drake, can be seen in front of Roy. *Courtesy of the author.*

MORE DECOYS TO CARVE

After the showing at the museum, I thought I would try my luck at carving a wood duck drake, as this is a most colorful bird and should make for a great decorative duck decoy carving. I had to order another block of wood from the same carving supply store for this decoy. This decoy carving wasn't started until July, but I was able to finish it some time in August. This duck is also in the Georgetown County Museum and can be viewed there. This was our second decoy. I say "our" because Roy has had a hand in every decoy that we have ever carved. He does what we call the rough cut and I do the finish work.

In September, Roy quit his job with Allen so he could carve with me full time. We wanted to see if we could make a go of carving decoys like our grandfather and his brothers, and whether we could make a living from it. And that is yet to be seen.

The only problem was that ordering one block of wood at a time proved to be just too expensive. We needed a better supplier of wood than where we had been ordering from.

After looking around and talking to a few people, I learned of a fellow who lived at Pawleys Island, Frank M. Beckham, who might just be able to help us out in that department. We gave him a call and sure enough, he had some wood on hand. He gave us driving directions to his home and off we went. Upon arriving, he met us at the door. We greeted each other and he took us into his home and showed us his carvings, which I thought were some of the most beautiful carvings I had ever seen. They were fantastic.

114

Our Decoy Carving Days: How It All Began for Us

The Caines boys with three of their decoys in February 2006—a pintail drake held by me, a mallard drake held by Roy and a black duck (carved only)—at an oyster roast on Mansfield Plantation. *Photo by Paige B. Sawyer.*

Afterward, he took us outside and showed us some wood he had, saying, "This is gum tupelo and it has been kiln-dried." We pretended we knew what he was talking about, but of course we had no idea what kiln-dried meant or what tupelo was. We only knew that it was what we needed, so we were thankful to have located some carving wood.

Frank showed us three large blocks he had. They were about three and a half feet long, eight by ten inches or so in diameter. It was enough wood to make about six decoys. "Oh man!" we stated, "this is just what we need."

We asked Frank how much he wanted for this tupelo. Frank told us not to worry about it, he wanted to help us out and give us a start. Boy, we couldn't have been more thankful. This wood was just what we needed. Frank told us, "Well, just do the Caines name proud and do a good job, that's all I can ask." We told him, "We'll do our best."

We started carving full-size decoys, with Roy doing the rough cut and me doing the finish work. By December of 2005, we had five completed decoys: a snakey-neck mallard, a wood duck, one we did from a picture of a carving done by Hucks Caines Sr., another mallard drake and a black duck. On December 4, there was a decoy show on Harkers Island in North Carolina. We thought we would go up there just to see what a show like that was all about. We had never been to anything like that, so we thought it might be a learning experience for us.

We hadn't been up there since we had bought the *Little Shrimper*, so we were looking forward to this trip. We took the three decoys that we had completed with

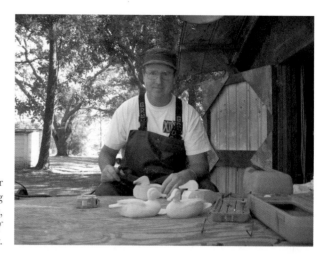

Roy Caines at our carving table making miniature duck decoys, March 2006. *Courtesy of the author.*

Me standing beside the guild's sign, December 2005. *Photo by Roy Caines.*

Roy Caines in front of the Decoy Carver's Guild headquarters, December 2005. *Courtesy of the author.*

us just to see what kind of a reaction they might bring from the experts up there. We went to a place called the Core Sound Decoy Carver's Guild. It was this guild that put on the show. We were welcomed with open arms, as a few of the members had heard of the Caines brothers and knew of their decoy work. Upon looking at our carvings, they thought we really had talent.

Once they found out we had been carving for less than a year, they were amazed at the quality of our work. We were told that usually it takes years to become a carver of that caliber. This was truly amazing to them, to say the least. And amazing to us, too.

At the show, we found out that some people were selling tupelo wood that was ready for carving. We purchased one block while at the show and paid twenty dollars for it. A little later we met another fellow, Tim Brown of Cape Fear Lumber Company, who was selling carving wood from the back of his pickup truck at the guild. He was selling his wood at a much lower cost than what we had seen at the show, which was taking place at the middle school more than a mile away. We picked out about seven or eight pieces, about sixty dollars worth. Tim told us if we went ahead and made it an even hundred dollars worth, he would throw in a couple of extra pieces. We agreed and proceeded to load up our truck. Upon getting our hundred dollars worth, this guy started tossing in more wood. We couldn't believe it. Why was he being so generous? He told us that he had heard of the Caines brothers and he, too, wanted to give us a hand in getting started. We couldn't thank him enough for his kindness and spent the better part of an hour talking with him.

Right beside his truck was another man who was selling decoys placed out on the tailgate of his truck. They called these people tailgaters, and they were all along the road and highway in the area during the festival. As it turned out, this man was Dick McIntyre. We started a conversation with him too. We also showed our carvings to him. He told us that the quality of our work was right up there with some of the best he had seen, although he said our carvings were contemporaries and in no way could match the prices that the older birds could bring. Collectors just aren't interested in fresh birds, but instead are interested in the older decoys. "That is where the money is and in a couple of years from now," he said, "you will find this to be true."

Well, this wasn't going to discourage us at all. No sir, we're still going to carve our decoys and see what we can do with them. I would love to prove that our carvings can have as much value as the older carvings carry and can become real collectors' items.

When we got back from our trip to Harkers Island, we went right to work on the carving of our decoys. I wanted to put more time into the making of each one and produce a much-improved decoy. Could it be done? I sure thought so. The painting of these decoys had to carry the same value as the carving to keep up the quality of

the work. I wanted to really put my best foot forward, to see what I could do when I put my mind to it.

Sometime in February, I was reading a book about the carving of decoys when I found out about a show that has been running for the last thirty-five years, the Ward Brothers World Championship Wildfowl Carving Competition and Festival held in Ocean City, Maryland. Their thirty-sixth show was coming up in April of 2006. This was perfect! If we could go to this show, we would be able to see what other carvers are producing and maybe pick up a few ideas for our own carvings. Plus, why not enter a couple of our decoys into the competition and see how they might do? It couldn't hurt.

In this book I was reading, *Carving and Painting Duck Decoys* by Jim Sprankle, there was contact information for the festival, so I wrote them a letter for more information. In about a week or two I got a reply. All the information we needed to enter this show was in their packet. We figured, why not? Let's go up there and see what this is all about.

On April 27, 2006, we entered four of our seven completed decoy carvings into this competition. They were entered into the decorative smoothie waterfowl division. This division is where you don't have to carve every feather on the decoy, but rather just have them painted on the smooth body of the bird. This was right up our alley.

Our decoys were not judged until the following Saturday morning. We were standing in the crowd across from the judges as they viewed the carvings in this division. Any markings that identified who had carved the decoy had been covered with colored tape so the judges had no idea who had carved each entry. I thought this was a very fair way to do the judging. This way, every carving had to stand on its own merit.

We watched in excitement, both Roy and I, as the judges picked up one of our entries, a pintail drake, looked it over and set it down only to pick it up again, look it over and set it down once again. They picked it up a third time and then passed it back and forth to each other. I was so excited I could hardly contain myself. Roy whispered to me, "I know that decoy has won a ribbon, they wouldn't be spending so much time on it otherwise."

Finally, they put it down and moved on to the next set of birds they had to judge. This is how it was working. Once they judged a group of decoys, they would hand a piece of paper to a floor runner who took the paper and left the area. A few moments later the runner would return with ribbons in hand and place them on the decoys in the order of the placement of the judges' decision. Sure enough, when they got to our pintail drake a ribbon was placed on it.

We couldn't see what position we had won, because with the judging still going on we had to keep back. I could hardly contain myself. Roy was excited too!

After a little while, the judges moved on to another area and we were allowed to enter the area and see where we had placed. We won second place. I was so excited

Our Decoy Carving Days: How It All Began for Us

Dick McIntyre on the right, selling from his truck tailgate, December 2005. *Courtesy of the author.*

Me in Ocean City, Maryland, right after winning a second-place red ribbon for my pintail drake duck decoy, April 29, 2006. *Photo by Roy Caines.*

Me in Ocean City, Maryland, right after winning a third-place ribbon for my canvasback drake duck decoy, April 29, 2006. *Photo by Roy Caines.*

Me in front of our carving shed standing next to my 1975 Camaro, February 2006. The *Little Shrimper* can be seen in the background. *Photo by Roy Caines.*

Me at our carving table, making our first attempt at mini decoys, March 2006. In the background my 1975 Camaro now rests where the *Little Shrimper* used to stand. She is now gone; she had to be destroyed due to rot. Our skiff can be seen now at rest. *Photo by Roy Caines.*

In front of the Kaminski House Museum in Georgetown, South Carolina, with a display of our decoys, April 16, 2006. *Courtesy of the author.*

that I didn't care where we had placed, only that we had gotten a ribbon. I was hoping for an honorable mention, but to receive a prize ribbon was well beyond my wildest dream.

Well, it wasn't over yet. I still had three more decoys in the competition. What were these going to do? Long story short, two decoys—the mallard drake and the pintail hen—received nothing. Our last decoy to get judged was our canvasback drake. It also won a ribbon; it took third place. I was truly ecstatic!

That evening, Roy and I went out to celebrate our victory. To us, this truly was a victory, as we hadn't known if we even had a chance at a show of this caliber. But this proved that we did. Our celebration was nothing more than a seafood platter at a fine restaurant in the area, but it was our celebration.

Once we were back in town, the word spread and we were able to make the front page of the *Georgetown Times*, our local newspaper. They had a great story and a color picture of us, each holding a prize-winning decoy and the ribbon that went with it. We were as proud as we could be, as we had done the name of the Caines brothers proud.

We have also started carving miniature decoys. We have about ten as of this writing. We are making these decoys about six inches long and carving them in the style of the Caines brothers, with their snakey-neck and heart-shaped wings. We are also making miniature decoys of pintails, mallards, canvasbacks and wood ducks in a more realistic style. There are more species in the planning stages, but these have not been realized yet.

Some of these decoys are to be given away to supporters of an upcoming festival that is to be held in Georgetown to celebrate the heritage and history of Winyah Bay and the surrounding waters. It is to be an event of fishing and hunting in celebration of how these things have affected the area and made this a great place to live.

The festival will kick off the first event in Georgetown, South Carolina, in the winter of 2007. It has been named the Winyah Bay Heritage Festival. It is to be held in January and is to be the start of an annual event, hopefully, for many years to come. Roy and I are to be the star artists at the first event of this festival. We are to display our latest decoy carvings and I will have my wildlife paintings on display as well. To say the least, we are both really looking forward to this. We have never had any kind of recognition like this and are right now making new decoys in preparation for this event.

We feel it's about time the Caines name was recognized for the heritage and history that it brought to the Carolina coast and to this area we call Winyah Bay. Well, that time has arrived!

Chapter 8

The Caines Family Genealogy
The Early Years to Present Day

The forefathers of the Caines families will be listed here as an ancestral chart and for the prosperity of their heritage. The Caineses are believed to be Irish or English and Irish. They were hard workers, stubborn and weather-beaten people who knew how to live off the land. They were survivors.

As far back as our known ancestry will take us, two brothers boarded a ship in England and headed for this new land called America. Their destination was to be a place called the Carolinas. As history tells us, one of the brothers settled in South Carolina while the other brother went farther north to North Carolina. The brother who settled in South Carolina was John Cain, who marred Anne Power on April 15, 1737, and gave birth to John Cain Jr. on May 7, 1737. It kind of makes you wonder whether this was a shotgun wedding. John Cain had settled in the Parish of Prince Frederick, South Carolina. The parish record book lists 1737 as the earliest date recorded for the Caines family.

The other brother was rumored to have left America and gone back to England, but no one knows for sure. It was thought that he had indeed returned at a later date and settled in North Carolina. There are Caines families that live in North Carolina today and they are believed to be the descendants of the other brother, but that's another story.

John Cain and his wife, Anne, had three more children: Sarah, born December 25, 1739; Hannah, born November 7, 1741; and Mary Hannah, born January 28, 1745.

The 1820 census for the Georgetown District lists John Cain III, the son of John Cain Jr., as born between 1780 and 1785 (the exact year is not known). John Cain III married a lady named Ann Hucks. They had one son, Richard C. Cains, and one daughter, name unknown. Richard C. Cains's second wife was Sarah Britton. Their children were Richard Randolph "Sawney" Caines; Sarah E. Caines, known as "Aunt Sally"; Martin Van Buerin Caines; Moultrie Johnson L. "Pluty" Caines;

The Caines Family Genealogy: The Early Years to Present Day

Joseph Jenkins Hucks Caines Jr.'s third son, William Hucks "Billy" Caines, died on July 9, 1961 at eighteen years old. He drowned due to stomach cramps while swimming in the Sampit River behind Georgetown, South Carolina. *Courtesy of the author.*

Gabriel A. Caines; Joseph Jenkins "Hucks" Caines, our grandfather, who was named after Judge Joseph Jenkins Hucks, a close friend of the family; and last, Robert "Bob" James Donaldson Caines. Edmund Alston "Ball" Caines was from Richard's first marriage, which made him Hucks's half-brother.

Joseph Jenkins Hucks Caines Sr. was born on March 9, 1876, and married Ida Viola McCormick of Socastee, South Carolina, on January 26, 1898. Ida was born on October 11, 1880. They had three children, born in this order: Ruby Violet Caines, born July 15, 1899; Bertie Ray Caines, born November 12, 1900; and Joseph Jenkins Hucks "Hucksie" Caines Jr., born September 18, 1908. Joseph Jenkins Hucks Caines Sr. is buried in the Caines burial ground at Fraser's Point on Hobcaw Barony. His wife, Ida Viola Caines, affectionately known as Ma-Ma, lived to be ninety-one years old and she is buried in Evergreen Cemetery in Jacksonville, Florida.

Our father, Joseph Jenkins Hucks Caines Jr., married Jeannie Veona Rourk of Shallotte, North Carolina, on April 11, 1936. Jeannie Veona Rourk Caines was born on May 5, 1914. Our parents had seven children in all, but the firstborn lived for only a few hours. Their children consisted of: Joseph Jenkins Hucks Caines III, born June 9, 1937, died June 10, 1937; Harrell Bell Caines, born August 1, 1939; Carol Jean Caines, born March 12, 1941; William Hucks "Billy" Caines, born May 26, 1943, died due to a drowning accident July 9, 1961; Jerry Wayne Caines,

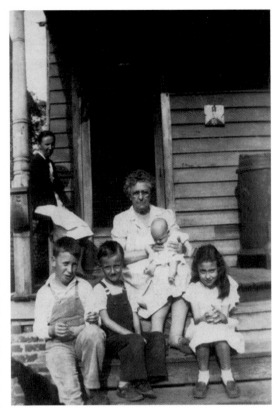

Back row: Dara Rourk, our grandmother on our mom's side; and Ida Viola McCormick Caines, our grandmother on our dad's side. *Front row:* Harrell Bell Caines; William Hucks "Billy" Caines; me; and Carol Jean Caines. August 1948. *Photo by Lester Lawimore.*

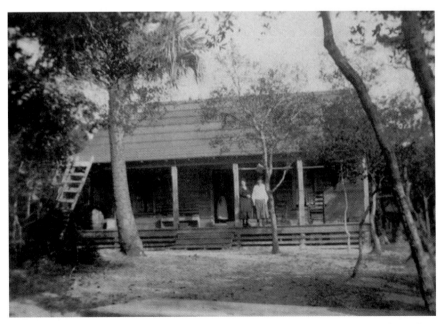

The house on Hobcaw Barony where Hucks and Ida Caines lived, circa 1920. *Courtesy of the author.*

The Caines Family Genealogy: The Early Years to Present Day

born August 8, 1948; Patricia Ann Caines, born January 12, 1951; and Roy Brooks Caines, born September 29, 1952. This was our family.

Just how the names Cain, Cains and Caines changed down through the years is anybody's guess. But change they did and we are known today as the Caines family.

Harrell Bell Caines married Bonita "Bonnie" Claradene Hughes on June 17, 1963. They had two sons, Harrell Bell Caines Jr. and Michael Scott Caines. Harrell Bell Caines Jr. has one son as of this writing, Harrell Bell Caines III, born June 29, 1994.

Carol Jean Caines married Danny L. Payton on March 27, 1965. They had three girls, Trina Sue Payton, Tracy Lynn Payton and Teresa Vern Payton. They call them the Three Ts.

Patricia Ann Caines married Eddie Levon Holmes on February 27, 1971. They have two children, Scott Wendell Holmes and Wendy Loraine Holmes. Wendy married Bill Shannon.

Sadly, Billy passed away before he could have married. Jerry and Roy have never married, but are still open to the idea.

About the Author

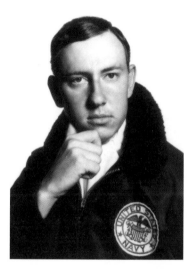

Jerry Wayne Caines was born August 8, 1948, and grew up in Georgetown, where he still lives and works today. He has been drawing and painting pictures since the late 1950s and turned professional in 1985. Jerry is a working artist and decoy carver along with his brother Roy, who is Jerry's partner in the making of their decoys. It seems to run in their family.

Jerry attended Winyah High School and went from there into the navy in 1969, where he spent four years in service. While in the navy, he did a tour in Vietnam. After discharge, he worked as a commercial fisherman until he started as a full-time artist. Today he is carving decorative duck decoys, which are made for the mantel rather than being used for hunting.

Please visit us at
www.historypress.net